The Secret Art Of Amateur Porn

A Beginner's Guide To Adult Home Movies

by T.J. Meier

Copyright Notice

Copyright © 5/8ths Media Lab 2013. All rights reserved. None of the materials in this publication may be used, reproduced or transmitted, in whole or in part, in any form or by any means, electronic or mechanical, including photocopying, recording or the use of any information storage and retrieval system, without permission in writing from the publisher.

First Edition: 2013

ISBN 978-1497417250

Trademark Disclaimer

Product names, logos, brands, URLs, web site links, and other trademarks featured or referred to within this publication or within any supplemental or related materials are the property of their respective trademark holders. These trademark holders are not affiliated with the author or publisher and the trademark holders do not sponsor or endorse our materials.

Copyright Acknowledgment

Photographs attributed to a third party are the property of such third party and are used here by permission. All such attributed photographs are subject to the copyright claims of each respective owner

No Guarantee Of Professional Advice

The following work is presented as an editorial, opinion piece. No warranty as to the correctness of the information presented is offered in any way.

Chapter 1
An Introduction & Key Concepts

You already have a general idea of what's needed to make amateur porn. You and your lover (maybe more) get together. You set up a camera, you strip down and you have sex in front of it. It seems, from that description, that there isn't much to it.

The truth is that there's a lot more to it than meets the eye. It's easy to set up a camera, have some sex and record it. You'll have sex on camera. However, just because you have sex on camera doesn't mean that it's good, well made, sexy, arousing or fun. It could be that the white balancing is off. The lighting might be terrible. The microphone is picking up all kinds of background noise. Maybe your framing is off. The light can be harsh and cold. You might have missed out one little detail or you might not have captured everything from the best angle. Maybe somebody's hair got in the way at that key moment and you missed the shot.

In short, there's a lot that can go wrong and there are a lot of little details that go into making good amateur porn. There are a lot of little traps that you can fall into and it's far easier to make bad porn than it is to make good porn. I won't lie, I made a lot of bad porn before I made anything that was watchable and I learned a lot along the way as I did. Most of it was learned by failing, learning from those

mistakes, applying the lessons and trying again.

That's why I wrote this book. I want to save you a lot of time, a lot of trouble, a lot of bad video and a lot of headaches. I want to jump you ahead in terms of experience without you having to make all the mistakes I did along the way to learn what you're supposed to do.

This book aims to fill your mind with useful, practical, relevant information. as well as techniques, and concepts to make you able to get better results when you first take a camera into your bedroom. We're going to talk about artistic concepts. We're going to talk about technical concepts. We're going to talk about practical tips like having water handy on a porn shoot. I'll show you how to get cheap equipment that will give you good results. I'll show you how to use items you already have to good effect. I'll show you how to get free video editing software and what kind of software you need. In short, this book will give you a solid foundation on which to build your amateur porn hobby.

The end result will be better amateur porn in your bedroom.

Defining The Scope Of Amateur Porn

Before we move on and really get into the technical aspects of beginning an amateur porn hobby, we need to talk a little philosophy. We need to determine just what constitutes amateur porn. What is it, exactly, that we're talking about in this book? We need a working definition. Let's start at the bottom and build our definition from the ground up.

The first thing that we should establish is who can be in amateur porn? The obvious answer is people who don't make porn for money. However, that isn't really accurate. In this day and age of the internet, many people make side incomes by making very explicit material, in their homes, for all of us to enjoy. These people are obviously not part of the "big budget, porn industry". In the world of explicit films, they are the equivalent of the mom and pop store. What they make is certainly "amateur porn".

What about the equipment? Perhaps this can be used as our dividing line between amateur porn and non-amateur porn.

Well, with this distinction, you'll find some problems as well. The truth is that equipment prices have fallen dramatically in the last twenty years.

With only a modest outlay of cash, any sex crazed couple in this world can obtain very sophisticated video equipment and processing abilities. In reality, much of the equipment that a sophisticated amateur would use would be very similar to the equipment used by professional porn producers.

It's true that many porn amateurs choose to use less sophisticated and inexpensive equipment, but this is by no means a rule.

We've talked about professional status. We have also talked about equipment. Unfortunately, neither of these options has given us a clear line that we can use to separate amateur and non-amateur porn.

Another common suggestion is that amateur porn consists only of real people in real relationships. Many people seem to think that only when a couple who has a real relationship films their intimate behavior for us, should it be considered amateur porn.

To that, I have a counter argument. Imagine that you happen to throw a swinger's orgy at your house. Amongst the rising human musk and against the backdrop of the sound of many happy people making love, you're walking around with a single camera recording the action. In this situation there

are all sorts of couplings going on, most with someone other than the someone they're in a relationship with. I think we can all agree that the end result would be something we could call "amateur porn". It would seem safe to say that amateur porn can certainly include sex with someone other than your significant other. Cellphone footage of that bar hookup in the bathroom would certainly be "amateur porn". Even if you never called her afterwards. So, again, we're left without a clear line.

But, I think we are left with a clue that we can use.

If explicit footage with someone other than our significant other, even if shot on professional equipment can be considered porn, even if we're going to make money on it, then perhaps we're closer than we thought.

All of this has really been a bit of an academic exercise to help flesh out the point that I'm going to make here. I did this, so that when I presented this, you will have already considered the definition from several angles.

For the rest of this book, this is the definition of "amateur porn" that we are going to use:

Amateur porn is the video recording, in one manner or another, or real people, having real sex, for real pleasure.

The essence of that statement is this. Big budget porn is produced by hiring people to have sex in front of a camera. They may certainly enjoy it and have fun doing it, but they're there because because someone is paying them to have sex in front of a camera. Amateur porn is different. People are having sex simply because they really enjoy the sex. They would still be having sex even if they weren't recording it.

In non-amateur porn people are having sex because the camera is there. In amateur porn, the camera is there because the people are having sex. The distinction is subtle, but important and this is what I'll be referring to as we move forward through the rest of our discussion.

Why Is Amateur Porn Special?

Amateur porn is something special. It really is. Don't pretend you disagree with me, especially if you're reading this book. You know I'm right. Just think about it.

Amateur porn is a lot like a specialty coffee, a craft

microbrew or a fine glass of artisan wine. Someone has taken the time to make it, because they wanted to make it. It's not mass produced. It's not cookie cutter made. It's unique. It has heart. There's a little something extra in it and you can tell the difference when you watch it and compare it to mass produced porn. It's hard to put your finger on, but you know it's there. Call it "soul" or "magic" or "spirit".

Amateur porn is special because it's something different from the porn that we're all accustomed to. Amateur porn is just that. It's amateur. It's regular people. There's no big budget special effects. Plots are completely absent. It shows regular people, having not always regular sex. More than that, it's real. Amateur porn is real people having real sex. The participants in a regular porno movie are paid actors. They may have shared a bagel at the cast snack table (yes, big budget porn sets have snack tables) before the shoot, but that's about the extent of their involvement with each other. That's not true in amateur porn. Real, amateur porn, I mean.

In real amateur porn (not big budget porn dressed up like amateur porn) the participants know each other. They have a relationship of some kind with each other, even a casual one like at a swinger's

orgy. They may have a history. They like each other. The physical attraction is real. They're having sex because they want to. There's a spark between them. The sex flows differently. It's natural. It's not choreographed. It happens, they laugh, they have fun. They make mistakes. Can't find the hole. There's a connection between the people that's genuine, not produced by the thought of the big check they get to cash for letting some guy cum on their face.

The "reality" is what people want to see and it's what makes amateur porn so special. That's why amateur porn, real amateur porn is so sought after. It's also why big budget, mass produced porn tries to emulate amateur porn so often.

It's a lot like diamonds. There are synthetic diamonds out there. They're made in a lab. However, they're nowhere near as valuable as the natural diamonds dug out of the ground. There's something special in real moments, captured on film that's the same as real diamonds dug out of the ground. The reality and the story behind it just make them both more enjoyable.

Why Do People Want To Watch You Having Sex?

People want to know what people do in the bedroom. They want to experience it. They want to see it. They just can't necessarily be a part of it. People are voyeurs plain and simple. That's why there's always a traffic backup when there's a car accident, even if the accident isn't blocking traffic. All of us want a quick few seconds to slow down, look, watch and observe. Sex is no different. People want to watch amateurs having sex, even when they say they don't.

There are lots of reasons. For one, it's really hot. Watching two novices is a lot of fun and it's really arousing. Now, I will not explain why it's arousing. It just is and, again, you know I'm right.

Two, is curiosity. People want to know what other people do when they have sex, what they look like naked, what faces they make when they cum. They want to know what their grooming habits are, where they're hairy, what their nipples look like and how big his cock is. All of it. People want to know and see all of that. Again, you can tell me I'm wrong but in your heart of hearts, again, you know I'm right. We're all just curious animals. We as people like to watch the gory details and now that public executions are off the table, watching some random

strangers try anal sex for the first time is as good a spectacle as we get.

Thirdly, people need to know what other people do in the bedroom. Now this might sound a lot like the second reason and at first glance, they do sound a like, but they're not. Here's what I mean. Sex and sexuality are private. People and society pretty much keep it under wraps, tucked away and secret. That means, unlike all the other areas in our life, we have trouble comparing notes. It's not appropriate to say "My cock curves a lot to the right. Can I look at yours and see if that's normal?" or "My pussy lips look weird. What do yours look like?" or "My husband makes weird noises when he cums. Does yours do that?". "I'm bored with my lover. Do you know any new sexual positions I can try?" I'll tell you right now, all of those questions will get you kicked out of book club, banned from softball or never invited to another dinner party. Our society frowns on them.

However, they 're good questions! More importantly, these are the kinds of questions that are in everybody's mind! We just can't ask them. That's where amateur porn comes in. We all want to watch, to look, learn, to study, observe and compare as much as we want to watch because it's hot and

because it's a spectacle.

We want to know what our neighbors are doing in their bedroom. We want to know what that guy at work looks like when he fucks his wife. We want to see the antics of the couple in the apartment across the hall, not the simulated product of screenwriter's imaginations, but the real, gritty, unedited amateur sex that happens all around us, everyday behind closed, secret doors.

Why Make Amateur Porn?

If you're reading this book, you probably have already decided that you want to make amateur porn on your own. However, a work of this kind would not be complete if I didn't take a few lines to go through some reasons you might be tempted to do so.

The first reason you might want to make an amateur porn movie is to immortalize part of your life. People buy cameras, either video or photographic, to record the important moments in their lives. They want to capture images that they want to remember and enjoy permanently. This means birthdays, weddings, anniversaries and the like. Why, however, should your sex life be any different? It shouldn't be. Sexual encounters are as

much worth remembering as any other event in your life, if not more so. An amateur porn video, whether shared or kept private, will do just that.

It's fun to be watched during sex too. However, not everyone is willing to invite someone into their bedroom to do just that. Maybe they need to preserve their privacy and remain somewhat anonymous. Maybe work, their peers, their neighbors or their congregations would not approve of them putting their sex life on display. Maybe they're just uncomfortable with that level of involvement and instead, prefer a little bit of a barrier between them and the fantasy.

Making an amateur porn video allows a happy medium. You can allow people a limited window into your bedroom, however, you can maintain your privacy and distance. I will tell you, it's a lot of fun knowing that people out in the world, who you don't even know, are watching the sexual antics you have recorded and are being turned on by them. It's a distinctly sinful pleasure.

Bringing a video camera into the bedroom is also a great way to spice things up. It's an erotic adventure. It's taboo, forbidden, something nice girls and boys don't do. That makes it much more fun to do. You're not supposed to and you know it.

It's like going out with your wife, pretending you're strangers, and then picking her up in a darkly lit bar. It's a lot of fun. You don't have to show it to anyone to get a thrill out of it either. Just knowing that you've done it will give you a jolt of excitement that may just prove addicting.

As a last bullet point, I'll say that once you have made an amateur porn movie, it's a lot of fun to watch after the fact. Beyond vainly immortalizing your life, it's a lot of fun to watch yourself on a large screen with your lover. It's sexy. It's arousing. It's like watching regular porn but your mind is flooded with the memories of sights, sounds, feelings and emotions from the act itself. It's like watching a memory, which is like watching normal porn on hallucinogenic love drugs (I'm not endorsing that, by the way). It's a lot better than you're used to.

There are a handful of, what I think, are convincing reasons to consider bringing a camera into your bedroom. As a closing note, I will just add, that if you never have tried making love in front of the lens of a camera; how do you know you don't like it? Life is to be experienced to be understood and making an amateur porn video is certainly something that everyone should cross off their

bucket list – at least once.

Amateur Porn Is Art...Make No Mistake

I feel that there's a very real need to clarify this point. Amateur porn is most certainly art. You might disagree with that. Porn is smut, filth, and disgusting right? The answer is absolutely not.

One simple definition of art is the representation, in images, of the emotion and soul that is the human condition. Yes, I did just make that up, but that makes it no less a real definition than any other. Working along those lines, I will extrapolate and explain.

Art is humankind's way of expressing intangible concepts and abstract conditions, like beauty and love, through permanent medium. An opera captures and portrays very abstract emotions through music and song. Abstract painting with little form or connection to reality can capture very complex thoughts like dreams, aspirations and innocence through the representation of paint on canvas. Non sequitur words fired staccato like the notes of a jazz song can very easily paint wonderful and deeply emotional pictures in our mind's eye without ever forming coherent sentences and paragraphs. All of these examples are very real art

forms that capture a little bit of humanity's soul.

How is amateur porn any different?

Sex, is an absolutely fundamental part of human existence. As a people, throughout time and space, we are obsessed with it. We all want it, need it, enjoy it, feel it, crave it and cherish it. When done right, sex is as close as people can come to actually mingling their souls. There is little doubt that there's something special in the sexual act.

Why then, should we not consider the visual capture and reproduction of these rarefied moments as art? Think about it. With the recording of these tender, innocent, orgasmic, pleasure filled couplings, the possibility exists to actually capture real human emotions in real sex on film. That's as close to the capturing an image of human souls as one can get.

Have fun with your amateur porn. Laugh. Giggle. Play. Get off on it. Let it arouse you and seduce you. Embrace it. Make it hot, passionate, lustful and sticky – really sexy art. But, never kid yourself and let your mind think that you're creating anything other than art.

Amateur Porn Should Only Include Willing, Legal Participants

I want to be really, really clear on this point. You should never, under any circumstances record anyone in any compromising position without their knowledge. It's OK to make your footage look like a secret camera recording. It can be part of the art. It's OK to hide your cameras so you and your lovers don't have to look at them and you can behave more naturally. However, it's never OK to record anyone doing anything without their knowledge and consent. That's completely unacceptable and may even be illegal. Plus, it's a dick thing to do. This is art, not exploitation, we're talking about.

Sex is about trust. When lovers trust each other, they can open up to one another and the sex is much, much better. Lovers need to be able to trust one another and that means that there should be no secrets. You can have a lot of fun taking your video equipment into the bedroom. It can be really hot and add a whole new, unexplored and forbidden dynamic to one's sex life. However, everyone should know about it and be a willing participant, just like the sex itself.

Two additional notes, before we finish off. Anyone in any porn you make should be of the legal age

consent. Add to that that you should and are required to follow any and all laws in your area. Period.

No excuses. No exceptions.

A Look Ahead

Thank you for putting up with me through a short academic exercise and through a few points and soliloquies that needed to happen. All of this has laid the groundwork for the rest of the discussion to follow. I promise, the rest of this book will have a different, more practical tone.

First, we will move on to talk about equipment. After all, you need gear to take up this hobby. After that we'll talk about how to set up an amateur porn shoot and then we'll follow with a discussion of tips and tricks to make your porn better and more artful. Lastly, I will include a few, but just a few, thoughts on post production in an appendix.

I'm as eager to get into the thick of it as you are, so let's move on in good order.

＃ Chapter 2
A Basic Equipment Considerations

Just about any hobby is going to require you to make some investment in equipment. If you play tennis, you are going to need a racquet and some balls. If you golf, you need a set of clubs. If you fish, you need a rod, reel and some bait.

You get the idea.

Amateur porn is no different. You're going to need some stuff before you proceed from the idea stage, to the practical application stage. This chapter will help you solve that particular problem.

We'll talk about some basic equipment considerations that you'll need to be familiar with before you start filming. Before we start, however, I want to make sure that you understand a few ideas.

The first idea is that this chapter is simply intended to function as a "primer". A primer is a first book about a subject. It's a basic, cursory outline – nothing more. This chapter is designed to give you key concepts and information, that you can then use to explore the specifics of equipment that you'll consider purchasing. Basically, I intended this chapter to be just good enough to allow you to ask educated questions before purchasing any particular type of equipment.

Additionally, you will find this chapter to be written in very broad strokes.

What do I mean by this?

I mean that in this chapter you will find discussions on universal features of equipment that aren't likely to be replaced by advances in technology. "Frame rates" and "aspect ratios" have been around since cameras and movies were invented. They're not going anywhere soon. However, you won't find a discussion on the various methods and technologies that cameras use to record their data, for example. This is intentional. This information is often more technical than the average user needs and these technologies are generally replaced in quick succession. Including information of this type would, sadly, in a few years make much of this chapter obsolete.

As such, I have opted against including it. Instead have limited myself to a chapter that can stand the test of time by focusing on the essentials – and only the essentials. That way, you can get through this little tome faster and get down to filming amateur porn. Which, if I am not mistaken is what you really want to be doing anyway.

Basic Video Camera Terminology

The camera is at the very heart of any amateur porn studio. Without it, you can't record anything. Because of this, we're first going to focus on and discuss satisfying your camera needs. But, before we can get into a discussion of going out and buying a new camera, looking for a good deal on a used one, or using a video camera you already have, it would be best to talk about some basic features of video recording technology. That way, you can approach your camera needs from a knowledgeable point of view.

First let's talk about the latest and greatest in video technology in a long time – HD. HD is a very popular term these days. Everyone is upgrading their televisions, DVD players and video recorders to HD. However, it should be noted, that at the time of this writing, the majority of world displays were still standard definition. If you have a camera and want to make amateur porn with it, or if you're going to buy a video camera with which to make amateur porn, you're probably wondering about HD. Let's kick it around for a bit and learn just what "HD" means. That way you can decide if it's truly necessary to your goals as an amateur porn artist.

HD is an abbreviation for "High Definition". This is a relative terms that's used to separate broadcast and display technologies from previous, "lower definition standards". In a nutshell, it's a combination of pixel density, aspect ratio and frame rate standards. Now I just threw a lot of jargon at you. Don't panic. I'll explain each one in turn.

Let's begin with the aspect ratio.

Aspect ratio is the the ratio between the horizontal and vertical sides of the television screen. Twenty years ago television was broadcast with a 4:3 aspect ratio. That means that the width of the frame was 4 parts and the height of the frame was 3 parts. Like this:

Since television was broadcast in 4:3, television manufacturers made televisions with screens in the 4:3 aspect ratio as well. Additionally, home video cameras were made for the 4:3 aspect ratio too. As time went on, however, television manufacturers began to experiment with a new aspect ratio.

This ratio is the 16:9 aspect ratio and this ratio is the industry standard these days. New televisions only come in 16:9. You won't be able to buy a new television with a 4:3 aspect ratio. That sizing, like dinosaurs and eight tracks, is gone forever. What this means to an amateur porn producer is that, to take full advantage of a modern television displays, you're going to want to make sure that any video recorder you buy will record in the 16:9 aspect ratio.

```
┌─────────────────────────────────────┐
│              16x Wide               │
│                                     │
│                                     │
│                              9x Tall│
│                                     │
│                                     │
└─────────────────────────────────────┘
```

What if you have a camera and it does not record in the 16:9 aspect ratio? The same thing that happens when you watch 4:3 television programs on a 16:9 television will happen. Black bars will appear on the side of the video frame. These are the pixels in the screen that are not getting any input signal and as such, remain pure black. These will take up the rest of the screen. Honestly, it's not the end of the world, in my opinion.

The 16:9 aspect ratio is an integral part of the "HD" system. Any recorder that states that it's HD will record in this ratio. If you have a camera that doesn't say HD, it's probably 4:3. Manufacturers like to make sure you know about high definition abilities. If they didn't it would be like having a turbo engine in a car and keeping it a secret. It just doesn't happen. For the record, just about any video camera you buy new these days will be at least 720 HD.

Next, let's talk vertical resolution. That's the 720 part I just mentioned.

Before we delve into the concept of resolution, we need to understand what pixels are. Pixels, are the small electronic flashes of light that, when taken together, make up a video or photographic image. If you own a digital camera you're probably familiar

with megapixels (MP). This means millions of pixels. We're used to seeing 10.1 MP, 15 MP or even 18 MP in photographic cameras. This means that the image that's recorded is made up of over 18 million little flashes of recorded light.

Just like digital cameras, televisions and video cameras are measured in terms of pixels. However, instead of taking a measurement of all the pixels like with a photographic camera, we talk in terms of vertical resolution. That is to say, how many pixels "high" the display is. HD video is either 720 pixels high or it's 1080 pixels high.

Both of these resolutions are referred to as HD and are part of the international standard, although 1080 resolutions are often referred to as "full" high definition. The important thing is that both of these display heights will result in a frame that is 16:9. So how does that work?

It's easy. Remember, 16:9 is just a ratio. In the case of a frame that is 720 pixels high, the width of the frame will be 1280 pixels. For every 16 pixels of width, there are 9 in height. Get it? With a frame that is 1080 pixels high, the standard width is 1920. Again, 16 pixels of width for every 9 of height.

How does all of this connect to the size of the

television or computer display? That's a great question and I'll explain it. The size of the television is constant. If you buy a 42" television, you'll always have a 42" television. That never changes. What does change is the screen's resolution.

Modern LCD and LED flat panel displays don't have a set number of pixels. The number of pixels that are shown change and are controlled by a processor in the television. This is really just a small, specialized computer. This computer analyzes the signal that the TV is receiving and then adjusts the pixels in the screen accordingly. If the video signal is 1080 HD, the screen will show 1080 vertical pixels. If it is 720 HD, the screen will show 720 vertical pixels. If it is 640x480 standard definition, the graphics processor will show that too, making adjustments accordingly. Pretty cool. Right?

When a TV manufacturer tells you that their screen will show full 1080 HD, they're telling you that that's the maximum vertical pixel height it will show. However, you can safely assume that it will show any resolution below that just fine as well.

Here is some fun food for thought. If you took a calculator and multiplied 1920 x 1080 (the pixels in

"full HD") you would wind up with the number 2,073,600. That's a little over 2 million pixels in the screen's resolution. If you translated that to a photographic camera rating, you would come up with 2.1 megapixels. I said before that with cameras it is very common these days to have 10.1 MP, 15.1 MP and even 18 MP. If I can buy a camera that can record 18 million pixels, why is it that my television can only show 2 million and my camcorder can record only 2 million?

The explanation is fairly simple. When you take a photograph, you record one split second in time. That's all you record. To do it well, you want to be able to record as much detail as possible. You want well defined lines, vivid colors and stark contrasts. If you were to blow that image up and hang it on your wall you would appreciate it by staring at an unmoving image. Now in that case, you need all that detail or the image will look bad and blurry.

Video is very different. You aren't recording one split second in time that you'll stare at. You're actually recording a series of moving pictures that will change as you watch the video. Think about it. All video is is a series of still pictures that change very slightly from one to the next.

With most modern video equipment those "still

pictures" are only shown for about 1/30 or 1/60 of a second. This is called the frame rate. It's a measurement of how often that "still picture" changes. With the images changing every .03 seconds, your eye can't study them in great enough detail to notice the lower resolution. You could, theoretically, record video at higher resolutions (you won't find a camera made to do it) but your eyes wouldn't be able to tell the difference. So with video, you can get away with lower resolutions than with still pictures and come away with great looking footage.

Frame rate, by the way, is the third part of HD.

Just like vertical pixel counts that both qualify as HD, there are several standard frame rates that can be called HD. Frame rate is measured in frames per second or "fps". The two dominant speeds are 60fps and 30fps. Higher frame rates result in smoother, more vivid looking motion on screen, but both are very good. A lot of smartphone cameras that are able to shoot in HD do so at 30fps.

With video equipment, it's not uncommon to see all of this information grouped together in a designation like "1080i60" or "1080p30". The "1080" refers to the pixel height. The "60" and "30" refer to the supported frame rates. You can always

assume a 16:9 aspect ratio.

I'm going to stop here and interject some personal opinion. Cameras these days can commonly shoot at 60 fps. I, actually, don't like this. There's a cinematic quality to movies that are filmed at lower rates, 30fps for example, that I feel disappears at 60fps. The resulting footage actually seems almost "too real". Believe it or not the footage, in my opinion, loses some of the warm, movie magic feel to it. When I shoot in the bedroom, I much prefer 30fps to 60fps. Consequently, if you have a camera that only shoots at 30fps, I feel that I can assure you with a clear conscience that it's plenty sufficient to the tasks ahead and you don't need to go out and buy a new camera. Just my opinion, take it or leave it.

I should also make a note about the "i" and the "p" that you see associated with HD video equipment. Both have to do with how the lines in the vertical resolution are scanned by the processors in the television. The "i" stands for "interlaced" and the "p" stands for progressive. These are features that are associated with televisions that display an HD signal. They are not part of the recording process. As such, you should forget all about them when you are considering which camera to use in your studio.

OK. We've talked at length about HD. Now what about "standard definition" (SD)?

SD recording is any recording that falls below 720 vertical pixels and is shot in the 4:3 aspect ratio. It's as simple as that.

Can I Use Standard Definition Video Equipment?

Of course! If you have a camera that shoots at less than 720 vertical pixels and does so in the 4:3 aspect ratio, you would be silly to just ignore it. I have a great camera that shoots in 640x480 at 4:3 and I love it. It's easy to use, reliable, takes great footage and is small enough that it isn't intrusive. I've had a lot of fun with that camera over the years – and recently. It definitely has a place of honor on my camera shelf.

Sure, when I play the video on a 16:9 television, those black bars appear, but it doesn't bother me. I'm usually much more involved in what is being shown between the black bars than I am in them anyway.

Before you go out and get yourself a brand new HD camera, you might want to stop and think a minute. All those sexy pictures in pin up magazines and on

the covers of check out aisle drama rags are all doctored images. Someone has gone thorough and made them look better than they really do. Blemishes are removed. Wrinkles disappear. Stretch marks are airbrushed out. It's not at all uncommon for photographers to intentionally blur their images ever so slightly to give them a softer, more pleasant appearance.

Time for a little more philosophy.

The truth is that you probably don't really want the absolute best picture you can get from your camera. A lot of the time less detail makes better looking, more attractive, easier to watch footage, especially in porn. Think back to all those arty and airbrushed men's magazines from the 1970's. They were sexy because you couldn't see everything and your mind filled in the detail. The same concept holds true today. Sometimes less is really more.

If you have a digital camcorder that shoots in sub-HD style don't dismiss it. I'm not talking about something you brace on your shoulder and load a video cassette into. I'm talking about a camcorder from a few years back that records digitally, just not in "HD". If you have one of those, blow the dust off and try that one out first. See what it does. See what it can do. Using that camera with the soft

lighting techniques I'll teach you shortly will actually give you some great results. Plus, you'll finally be able to get your money's worth out of that camera. Recording your kid's soccer games was boring. This will be much better. I promise.

Don't forget, if you try it and decide you hate it, you've lost nothing and then you can go out and get the most expensive HD camera you can find without any guilt.

File Quality = File Size

Something you should be aware of is that the better quality of recorded images in a video file, say HD vs. SD, the larger that recorded file will be. Each one of those pixels in a frame, at 60 frames a second, requires data to be stored into a file on a computer. Better quality means bigger files. Period.

If you're recording your sexcapades onto a DVD or a hard drive for personal enjoyment and fun walks down memory lane, that shouldn't be a problem. Computers come with huge hard drives these days and by the time you fill one up and have to delete the earliest video in there, you'll probably be bored with it anyways.

On the other hand, if you're giving any thought to sharing these videos, especially on the internet, file size becomes very important. The larger a file the longer it takes to upload and download. The larger a file, the longer it takes for a viewer to download. Horny people don't like to wait forever for their porn to queue up. The larger a file, the more space it takes up on hosting sites and server hard drives as well. These are both negative.

In short, if you're planning on sharing your naughty art creations on the internet, you need to think about the size of your file ahead of time. Standard definition video equipment will make smaller files naturally. Add to this fact what I've already said about less detail being better. Then throw in the fact that non-HD equipment is cheaper and easy to come by and you'll see why this type of equipment is a natural, easy place to start for any amateur porn producer.

You Might Even Have A Porn Camera Without Realizing It

Before you drop everything and go out and spend a bunch of money needlessly on a brand new HD video camera, you might want to take a minute to think about video cameras you might have lying around.

The first place I would tell you to look is your cell phone. Is it a smartphone? A lot of phones are these days and many of them come with very sophisticated camera packages capable of full 1080 resolution at 30 or 60 fps. Check your specs. Review your manual. If you like what you have, you can easily use this and even mount it on the tripods we'll talk about in a minute with some helpful adapters. Go to your favorite retailer and look for "smartphone tripod adapter".

Another place you might have a great camera to shoot amateur porn with, without even realizing it, is in a point and shoot camera.

Remember those?

They were what everyone used to take pictures before everyone had a smartphone. While the market has been savagely taken over by smartphones, millions upon millions of them were sold prior to that. I personally, have a bunch in the house. I wouldn't be surprised if you do too.

Well, the truth is that many of those cameras came equipped with quality video recording abilities as well. Many were even on the cutting edge of 720 HD. Remember, full HD is only around 2 MP and a lot of these cameras were sold in the 10-16 MP

range. The sensor in these cameras could easily have been retasked as a video camera. Many were in fact. Additionally, as these units were originally designed as photographic equipment, they already can be easily mounted to a tripod. No adapter needed!

Before running out and buying a camera, look at these two options and see if either one is a reality for you. If so, great. Later, we'll talk about a setup that requires three cameras, so truth be told, the more cameras, the better and you may still even get to buy something new and shiny to play with.

Getting Cameras On The Cheap

If you decide that you do have to go out and buy one or more cameras, there is no sense in paying more than you have to. I'm going to give you three options that might help you find high quality video equipment at lower prices than you might expect. I've successfully used all three of these to save a buck.

The first tip I'll give you is to look for refurbished equipment.

Refurbished equipment is equipment that had some sort of material defect in it when it left the factory.

One way or another, it came back. Once back with the manufacturer, it was repaired, retested and repackaged in new condition. However, since it had already been sold and was technically "used" the manufacturer had to call it "refurbished".

I'm a big fan of this type of equipment. First off, there's the price. Usually, you'll pay about half the retail price for an item in the same condition as a new one. Also, refurbished equipment is usually top notch. The manufacturer will put the equipment through a thorough series of testing to make sure things are up to specifications. Nobody wants something coming back a second time. That just causes a lot of headaches. I've bought lots of refurbished equipment in my time from computers to vacuums to video equipment and I've always been satisfied with the purchase. Plus, I loved the low prices.

It's definitely worth checking out. Many online retailers will offer you prices in either "New", "Used" or "Refurbished". You owe it to yourself to check out that third category.

I prefer refurbished because they usually come with a warranty, come in like new condition and have a manufacturer's backing. That being, said, I'm not above buying used equipment either.

Used does not mean bad. A lot of the time people upgrade equipment for one reason or another. Cell phones, computers and cars are all common items to be upgraded. However, the used ones are often still in very good condition and might serve your purposes well. How many "pre-owned" vehicles are sold every day in the world? They're all used and they're mostly good. Video cameras are no different.

That being said, you need to be a little more careful when you buy used video equipment whether it's face to face or online. Check it out. Test the equipment. If it's online, make sure you look at the online reputation of the seller. Do they have happy customers and a high rating or lots of complaints? Also, see what, if any, is their return policy. A retailer who has a return policy that they'll stand by is usually not going to sell you a defective product. A seller who does not accept returns is usually one you want to pass by. It's just not worth the risk in most cases.

If you can, download and read the product manual before you buy it. Most reputable electronics manufacturers have these on their websites, along with product specifications. This way, you can test important features and look for anything out of the

ordinary. Reading the manual will also allow you to ask questions from an educated point of view. As you might be able to tell by now, I'm a big fan of that.

Just remember, when buy used equipment, the rules are "Buyer beware" and "If it sounds to good to be true it probably is".

The last tip I'll give you for getting cheap equipment is at pawn shops. Pawn shops are great places and a lot of fun. You never know what you'll find in a pawn shop and sometimes, you can get a great deal. If there's a pawnshop in your area, go check it out. See what they have. Take a pen and paper and write down any model numbers and prices you come across.

Then, walk out of the store.

Go home and do a little homework on what you saw. Are the prices fair? Will the equipment serve the purposes you have in mind? Are the specs up to snuff? If so, go back, test everything out and make a fair offer. In fact, try to lowball them. It's fun. Remember, everything is negotiable in a pawnshop and wheeling and dealing is part of the adventure.

Chances are one of these options will help you find

a great camera at a lower price than ordinary retail.

Extra Batteries & AC Power Supplies

You and your lover might find that having sex in front of a camera is just what's been missing from your bedroom. If that's the case, you certainly want to keep those cameras running and keep having great sex on film. There's just one problem. Cameras run on electricity and you need to keep them powered to make sure they keep working and recording.

To that end, it's great planning ahead to make sure you have extra batteries or an AC power supply with you anytime you want to set up a little adult movie shoot. They should always be in your camera bag and they should be on your checklist anytime you go anywhere with your camera. Most of the time you won't need them, but the one time you do, you'll be happy that you have them.

Finding extra batteries is easy enough. You can simply buy a few extras from wherever you bought your cameras. If this isn't an option for some reason, jump online with your model number and I'm sure you'll find what you're looking for.

I will give you a few words of warning about extra

batteries though.

Although you can frequently buy cheap, generic batteries online, and the prices will often be a small fraction of what the camera manufacturer will charge for theirs, not all batteries are created equally. I'm as guilty of using batteries from suppliers other than my camera manufacturer as anyone. They usually work pretty well, but sometimes advanced power features of your camera will not work with the generic ones. Software incompatibility and manufacturing variances creep in. This can cause problems with, for example, your camera's "time remaining in battery" readings. As with most things in this book, the ultimate decision is yours, but don't say I didn't warn you.

If you want to avoid batteries altogether and run your cameras for hours while you and your lover engage in a full on sex marathon, you're going to need an AC adapter. This is the cord with the big black box that plugs into your camera and your wall outlet. These devices convert household AC power to the DC format your cameras use. These cords provide an unlimited source of power and will keep your cameras running until your power company shuts you off. They're great for those rainy days when you two want to stay inside and play.

Most cameras have a port on them that will say something like "DC IN" and will then list a voltage like "3.6 V". This tells you what voltage rating your camera will need from the AC adapter. Consult your manual for information specific to your model. Most of the time, camera manufacturers will make AC power supplies that are pretty cost effective that work specifically with your camera. I usually stick with one of these, although, again, generics are available at a bit of a discount.

Camera Shake & Tripods

Some people might call me a tripod snob, but I hate camera shake. It's noticeable, distracting and totally preventable.

Camera shake is another term from photography that has relevance to our discussions of amateur porn. "Camera shake" is when the camera moves slightly for one reason or another while it's recording images. The camera just sort of wobbles or jiggles from time to time. This is especially bad in still photography as it can ruin a shot. However, it's certainly undesirable when you are recording video as well.

The reason is simple. The visual effect of a wildly

or even subtly moving camera can be disorienting, distracting and leaves the viewer with a feeling that they're on a roller coaster. If you're unclear on what I mean, or want to see things first hand, just get on your bed with a video camera and bounce up and down. When you watch the video, you'll get motion sickness. We want to avoid this. Ideally, cameras in amateur porn should not be moving at all since there's generally not a camera operator to make informed, dispassionate, artful decisions while the scene is unfolding. Ideally, the cameras should be stationary and left untouched to silently, objectively record what is in front of them.

You could just prop the camera up on a bookshelf. That's one option. However, if you make enough amateur porn, you'll learn that without exception the camera will always choose the absolute worst and inopportune time to fall over. Then, if you even notice, you have to stop the scene, ruin the magic and go fix your equipment. That is, again, if you even notice. If you don't notice immediately, you'll only realize it after the fact and when you've missed out on everything that's already happened. In that case, the magic happened, but it's lost for all time. Neither one of these is a good option.

What you need to do is what the professionals do.

You need to use tripods.

Buying a tripod will make your amateur porn much better from the get go. Tripods are basic, cheap equipment that are necessary to get the really good footage. Trust me on this one.

There are a lot of tripod options out there. You can get basic aluminum frame tripods that's reliable and inexpensive. You can buy the latest in carbon fiber backpacker tripods that are ultralight weight, but are more expensive. You can buy a ball head or a basic three plane platform tripod. Long story short, there are a lots and lots of options.

There are a few basic considerations that we need to consider first. We need something that will hold the camera steady. The truth is, almost any tripod out there will hold your video camera reasonably steady. This is enough to eliminate noticeable camera shake in most cases. Some are better than others and you should test them before you rely on them in a shoot, but most will do a pretty good job holding the camera steady. Remember, video imagery is shot at a much lower resolution than still photography, so you don't need to buy the greatest professional photographer's tripod. Good enough will do just fine in this case.

Beyond steady, we should think about size. Some tripods can get pretty big and take up a lot of real estate on the floor. This is fine in a spacious master suite, however, it can become a problem in a hotel room. You don't want to get to the location where you're shooting only to find out that your tripod is too big to set up. That's not fun.

Lastly, you need to think about height.

We will talk later about setting up different camera perspectives to best capture a scene. This will require some tripods that offer height. Again, you can use a bookshelf or another tall piece of furniture, but you can't always be sure one will be available. A bookshelf does not solve the problem of your camera tipping over either. If you get to the orgy hoping to get high perspective (more on this later) and find that they have no high furniture, you're going to have a problem.

In my opinion, the reality is that one tripod will not satisfy every camera need. Instead, what you'll probably want to do is purchase three tripods. This will actually be really helpful for a technique I'll introduce to you shortly anyway. Purchase one standard aluminum tripod that will give you somewhere close to 60" or about 150cm. Also, purchase a small "table top" tripod. These tripods

stand less than 12" tall and are used for product photography and macro shots. They also come in really handy when stability is needed, yet space is limited. These tripods are small but can support a lot of weight reliably as well, so any camera you throw at them will work.

Beyond these two types of tripods, I would also recommend getting a small "flex leg" mini tripod. These very small tripods are popular with recreational photographers and vacationers. They are less than 6" tall and easily fit into a pocket. They are quick to set up and can provide good stability and perspective for small cameras and video recorders. One of these little guys will be invaluable when space is an issue and you need to get a camera placed in that one tight space.

I've just told you to go and buy three tripods to give you stability, reliability, flexibility and to eliminate camera shake and offer perspective opportunities (again more on that later). This might seem like a lot and you might be balking at the idea of how much these are going to cost you. That's the good part. The truth is that you can easily purchase all of these tripods for less that $75 - combined. That last part sounded like an infomercial pitch. I'm not selling these. Don't worry. I'm not even going to

pimp where you should buy them. Jump online or go to your favorite retailer that sells camera equipment and you'll find what I'm talking about at very reasonable prices, plus lots of selection. However, seriously think about buying all three. To a photographer or videographer, after the cameras, there is no more important equipment than the tripods. They're that essential!

Microphone Solutions For The Amateur Porn Artist

If you want to include sound in your movie, and I'll remind you that sound is just as important to arousal as any of the other senses, you'll probably want to consider purchasing an external microphone. Now before you ask, yes, most video cameras, digital cameras and camera enabled smartphones do have microphones built into them. But, like all things, the devil is in the detail. It won't take you long in your movie making hobby to realize that not all microphones are the same.

The type of microphone that's included in most consumer grade video cameras and even expensive digital SLRs are called "omnidirectional" microphones. "Omni" is a derivative of the Latin word "omnis" meaning "everything". As such, it should come as no surprise to you that an

omnidirectional microphone is designed to pick up sounds from all around it. This means that they'll pick up and record subtle background noise, annoying high frequency air movements that'll sound like someone is blowing on the mic or even noise from outside your window. You can clean these tracks up in audio post production, but they'll never be what you would call "ideal".

The microphone that you may want to consider purchasing to replace the omnidirectional one, and thus eliminate all of these problems, is called a "unidirectional" microphone. These microphones, are designed to allow the user to narrow in and focus on one sound source, say a couple having sex. At the same time, these microphones block out ambient background noises that would be distracting on the final audio track.

My personal favorite microphone of this type is a so called "shotgun" microphone. This unit features a long tube that resembles the barrel of a shotgun. The barrel can be covered with a noise dampening foam covering for added background noise reduction.

Like all things audio/visual, the cost of unidirectional microphones has fallen quite a bit and you can easily buy reliable "good enough" units

for under $100. Doing so will save you a lot of audio headaches. Do an internet search for "unidirectional microphone kit". You'll find plenty of options. I strongly recommend buying one if you want sound in your movie.

Before going out and buying an external microphone kit, you first need to determine if your equipment can accept external audio input. Look for an external 1/8th inch microphone jack (see photo) on your camera. Most video cameras will have one. Most SLR digital cameras that can record video will have one. In my personal experience, most point and shoot style digital cameras, that can record video do not. Many smartphones do have built in microphone jacks of the necessary type, but whether or not you can feed that input into the video program will be heavily model dependent. Again, consult your manual.

Many microphone kits come with equipment to mount to the "hot shoe" of a camcorder or SLR as well. This is the part on top of the camera where you attach the flash. If your camera does not have one of these, don't worry. Most kits also come with equipment to mount the microphone on a tripod. This means you may need to add a fourth tripod to your toolbox. Plan ahead and make sure you have

enough tripods before you are ready to shoot.

External microphones connect to your video camera using a .125 inch adapter like this one shown here. Look for a matching port with the word "mic" next to it.

Lighting Options

When filming your scene you have several choices to supply the light that you'll need to properly record the action. Remember photography and videography are nothing more than the art of recording light. This means that lighting is really, really important.

Natural lighting is absolutely amazing for lighting up an amateur porn scene. All too often, amateur

porn artists overlook this option to their detriment. Obviously, if you have a secluded pool, jacuzzi or a chez lounge on a patio somewhere, you can film under a naturally blue sky in full daylight to record brilliant colors and imagery. However, you can use natural light inside as well if privacy in your yard or deck is missing. Just open a window.

This won't work in a densely packed urban environment where anyone with a telescope can spy what you and your lover are up to, but that doesn't mean natural light is always out. What if you and your lover go off on vacation together to some large hotel overlooking a Caribbean beach? Those hotels all have private balconies with big, bright windows looking right out onto an unending horizon. No one is going to be looking in at you in a setting like that. Maybe you're one of the lucky few and your home features something just like this. A cliff, even far from water, will provide the same sort of privacy I'm talking about and will allow you to open the blinds to fill your set with perfect, natural light. Southern California is full of houses like this.

If you're so lucky, go for it, experiment and see how it works. One suggestion I would make, is that if you plan on using natural light, use a diffuser. Get a thin sheer white curtain to cover the window. This

will add a touch of privacy just in case, but will also scatter the outdoor light and create a softer, arty, airbrushed feel in the final recording.

If those options aren't possible, don't forget about skylights. A skylight in your home, on a sunny day, will bathe the room under it with wonderful light to shoot video. Sometimes, to find the absolute perfect lighting, all you need to do is look up. Don't forget that.

If you can't shoot outdoors and your bedroom window looks right in at your neighbors house you're going to have to use artificial light. This isn't a problem. The majority of movies and television are filmed under artificial light. Modern photography lights are good and your porn will be just fine under artificial light too.

You might be tempted to go buy studio lights like the one shown on the cover of this book. You can find lights like that on the internet for about $100 and I will say, they're really useful. They can easily throw out 1000W of bright light and will create a very nice balanced look in your final video.

The truth is, however, that for amateur porn, they might be a little more than you need in the beginning. They throw out more light than is

absolutely necessary and are designed more for photography when you want lots and lots of light to get all the details possible. In porn, that isn't what we're looking for. We're looking for soft, gentle, warm lighting that shows just enough detail, but not too much.

To get that "just right" lighting, all you really need are basic household lamps.

Basic household lamps, if you have 2-4 of them and they're loaded with 100W incandescent or compact fluorescent equivalents, will put out more than enough light to record everything that you want. They will however, leave things dim enough to offer that pleasing arty and airbrushed look that you get from diffused, natural light. We'll talk more about artificially darkening your final video in a later chapter.

With household lamps, it's really just a case of trial and error. Get some lamps, put in your bulbs and fire them up. Set up your camera and see how things look. Is it too dim? If so, get more lamps. That's pretty simple. If it's too bright, you can lower the wattage rating on your lights. Drop it down into the 60-75W range and see how that works. You should be able to find something that works for you pretty quickly.

I would avoid overhead lighting unless it's through a skylight. Overhead bedroom lights, although powerful enough to light your scene, will offer a harsh look on the finished video. That, plus the fact they tend to throw a lot of distracting shadows makes overhead household lighting undesirable for amateur porn.

Some of you out there might also be tempted to try candles. You might be thinking that they'll romance it up a bit and give your porn some class. Don't even bother. Candles look nice when you're making love, but they have no place in amateur porn. They don't throw off nearly enough light to make a difference and they do cast a lot of shadows and really heat up a room. Both of these facts mean that you should leave candles for another time when the cameras aren't rolling.

A Cheap Diffuse Lighting Setup

Wedding photographers have a trick to create natural, soft, attractive lighting when they're shooting. They can't rely on having large, bulky lights everywhere they need them so they use flashes. However, a powerful flash on its own can also create problems with overexposure and harsh lighting. What they do is they scatter, or diffuse, the light. This creates a softer, warmer light effect

in the finished photos, without the need for distracting flashes or bulky, intrusive photo flood lights.

How do they do this?

Wedding photographers will point the flash of their camera up toward the ceiling, which is usually white and literally bounce the light off the ceiling. This scatters the light and creates the softer end result they want, but it doesn't significantly diminish the brightness of the recorded scene.

This same technique can be very easily adapted to the art of amateur porn with a few simple pieces of equipment and a white ceiling. Luckily, in many homes, no matter what room we're talking about, the ceiling is white. That's good for us.

All you need to buy to do this is some "torch" style lamps. These are the tall lights that have an upward facing shade. You can buy these for as little as $5 thanks to the benefits of global trade. I would recommend buying four of them. This will allow you to put one in each corner of the room and create a balanced lighting solution. Don't worry about what light balancing is at this point, we'll talk about that in the next chapter.

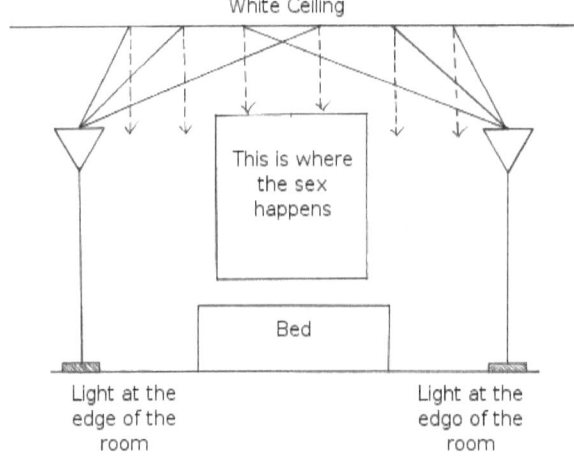

Once you have the lights, get the highest wattage light bulb that the lights can safely use. There should be a sticker on them saying what the maximum wattage rating is. Then, pop those babies in there. Crank up the lights. The light goes up, hits the white ceiling and is reflected in a scattered pattern all over the room. This should flood the room you'll be shooting in with soft, natural looking, warm light. This will be soft enough to create ambiance, yet bright enough to allow your cameras to catch all of the action.

Cheap and efficient. That doesn't happen very often.

I Prefer Soft Incandescent Lighting

A lot of homes these days are lit by compact fluorescent light bulbs. There's little wonder in this as these light bulbs are much more energy efficient. In many cases, they use less than half the amount of electricity as other light bulbs. That's great. I'm as much a fan of saving the environment as the next person. However, great these light bulbs are at lighting a room, they do have some drawbacks when it comes to making amateur porn.

It's the actual light that they put off, specifically the wavelength of the light. Fluorescent lights put off more light in the blue color spectrum, whereas incandescent lights put off more light in the red color spectrum. The additional blue light over red light tends to give fluorescent lights a "cooler" feeling. Incandescent lights have a "warmer" feeling.

When you're filming amateur porn you'll often find that if you use softer, warmer light like that put off by an incandescent bulb, you'll wind up with better looking, more appealing, footage. The soft light can hide imperfections and create softer, blurrier lines on the video. It helps with that arty and airbrushed look I've mentioned before. The warmer light, like that of a crackling wood fire, will help to

create a relaxed, sexy feel as well.

The one drawback if incandescent lighting over fluorescent is that they're hotter. These light bulbs produce light by running electricity through a metal wire until it's literally glowing. This can put off a lot of heat in a small room. However, in my opinion, the heat is a small trade off for the ambiance they create.

Camera, Tripods, Microphones & Lights

The heading says it all. These are the four pieces of equipment that are essential to beginning your amateur porn hobby. After what you've read in this chapter, I feel comfortable that you have all the knowledge that you'll need to go out and find reasonably priced, reliable equipment that meets your particular needs.

Once you've got all the gear you require, all you'll have left to do is put it to use. The next chapter focuses on exactly that. There we'll talk about how to set up and use your new equipment in your very own amateur porn studio.

Chapter 3
Setting Up Your Scene

One of the biggest differences between the "big budget" porn industry and the amateur scene is that big budget productions have a staff. Most importantly among them are the camera operator and the director. It's their combined job to set up the scene to be filmed and to make adjustments during filming to best record it.

You, as the amateur will wear both of these hats. However, most likely, you'll also be starring in the video production as well. You won't be behind the camera and you won't be able to make those adjustments during filming. That means that you need to set everything up, just the way you want it, so it can run autonomously without any input from you during the shoot. That way, you can focus on the more important details that are happening in front of the camera.

To say that this is the most challenging hurdle for any amateur porn producer to overcome would be an understatement. But don't worry! This book is here to help you jump that very hurdle.

In this chapter, we're going to talk about how to go about setting up an amateur porn scene that can run on its own without any help from you. We'll also talk about tricks to help you capture more footage and not miss out on the important happenings.

Lastly, we'll talk about how to set, calibrate and operate your equipment to maximize the artistic effect and provide you with the best results.

Roll up your sleeves. We're in the thick of it now.

But First, A Pep Talk

Video editing, or post production, can do a lot to make your footage better. You can easily edit together pieces of footage to show sex in new and unique ways. You can fix minor mistakes and make many useful, small adjustments. What video editing software cannot do, however, is make bad footage good. Like I said, it can help to fix a minor problem here and there, like white balancing and background noise, but it's not a panacea cure all to fix the shortcomings of bad amateur porn artists.

Video editing software cannot reframe your shots. It cannot relight badly lit scenes. It cannot miraculously create shots that you missed when you set up your cameras with blind spots. Those tasks are the responsibilities of the producer/director – i.e. you.

You should never rely on editing software to fix your mistakes. Never think to yourself that it's OK to not worry about the small details and that you can

just fix things in post production. The best way to make good amateur porn is to make it good when you're filming. Set up your shoot correctly. Pay attention to details, check lighting levels, adjust your framing, test your equipment before you start the sex. That's just a few. If you pay attention to these little details, which really are pretty easy, and you capture good footage right from the start, you'll wind up with better porn in the end.

Just pay attention to details, worry about the small things and everything will be fine.

Studio Locations For Beginners

Deciding where you're going to film is one of the most important decisions that you can make as a film producer. You need to give this a little thought because a badly selected location can just ruin your film. I have seen people make all kinds of odd choices when it comes to filming their sexual antics. Hallways and kitchens are bad choices. Natural, believable, enjoyable sex rarely happens in a hallway or a kitchen.

Now you might think that this is an unimportant, trivial decision. It's not. People don't usually have sex in these places for a reason. They aren't comfortable. That's still true if you have a camera

rolling. Adding a camera and some lights does not suddenly make a countertop soft or a floor inviting. That means that the people having sex in that space will most likely be uncomfortable and as a result will enjoy themselves less. This will be tangible in the finished movie. Remember, if you and your partners are uncomfortable, you'll enjoy sex less and it will result in a poor finished product.

You can shoot a quickie in these places. That CAN work, but you should never plan on doing any sort of lengthy shooting in an uncomfortable place. Extended shooting should be done somewhere plush, soft and comfy.

In reality, this leaves two options that are good for the beginner. You should use either a bedroom or a living room. I'm a huge fan of sectional couches and they can make an absolutely fabulous place to have sex and to film it, stains not withstanding. Either choice will work very well, however. Add to that that a master bedroom and a living room are usually larger, more spacious rooms. This means more room for equipment, more room to play and more video recording options. All these facts make bedrooms and living rooms a natural pair of winners that you should stick to at first.

Avoid Staging

I want you to recall that amateur porn is all about reality. Real people. Real sex. Real pleasure. The reality is what draws a viewer in. It would not be a misnomer to call amateur porn, "reality porn" instead.

That being said, I would caution you against staging too much. By staging, I mean the deliberate placement of props, furniture, backdrops, etc. to create the set where you'll film your sex. Set creation and staging are done very well by the professional porn industry, but the truth is that when amateurs do it, it usually comes up short. It looks fake because it is fake and that artificial quality ruins the reality of the porn. In the end you wind up with badly done, badly choreographed amateur porn trying to be something it's not. It's not good amateur porn at that point.

Instead, play to the strengths of reality porn and embrace it. Don't primp. Shoot your scene in a set that's real. You can clean up, I have nothing against that, but don't rearrange. Shooting in your real living room or your real bedroom on your real furniture, will produce a better movie in the end.

Ensure You Won't Be Disturbed

You might laugh and think that you don't need to be told this, but trust me, there are people out there who do. Wherever you're filming your porn, make sure you won't be disturbed. Lock the front door or lock your bedroom door or double bolt the hotel room door. Use the chain. I've had maids walk in on me and only the chain stopped them. The last thing you want is some maid screaming when she walks in on you tied up, surrounded by people wearing masks sporting giant, brightly colored, silicone strap-on dildos. Put out the "Do Not Disturb" sign anyway. Make sure the kids can't walk in on you and your lover when they come home early from soccer practice Make sure your mom can't open the door even when she tries really hard.

A little attention to detail here and making the effort to maintain your privacy ahead of time, will save you lots of embarrassment and potential money for therapy later. Think of a good lock as a cheap insurance policy.

Single Camera Placement

Once you have your location chosen, and the door is locked, the next most important step is placing your

camera. After all, without that, there's no amateur porn. The truth is, that if you're placing only one camera (we'll talk about multiple cameras next) there's not that much of a trick to it. Place the camera, on an appropriate tripod, about 8-10 feet (2.5 -3 meters) from where you intend all of the action to happen.

Do make sure of a couple of things though. First, make sure that there's no chance that the camera will be knocked over during any of the coming fun. It should be well clear of all the participants in the porno. An errant arm or a leg convulsing in the midst of ecstasy can easily knock a camera over without meaning to. This is bad for two reasons. The first is the camera might be damaged. No matter where you got your camera and no matter how much you paid for it, you don't want to see it broken. That puts you back at square one. More importantly, the crashing will ruin any magic and flow that you and your partner had going. No director in the world wants his/her actors disturbed while they're filming gold. Beyond that, it could wake the kids, and at that point, you'll wish that the two of you had just started putting together a jigsaw puzzle instead.

You should also make sure all of the tripod nobs are

good and locked. Not just a little. Make sure they're really tight. If they're not, the camera may move during shooting, so slowly that you don't even notice, and ruin the shot. Don't make this mistake. Lock everything in now!

You might be tempted to think from the brevity of this section that setting up a camera is as simple as just picking a spot. There's actually a lot more to be done before you as the director can call action, but for now, we'll leave it at that. I want to move on and discuss multiple cameras before we talk about the subtle nuances and artful decisions, you as the director will need to make regarding the camera.

The Triangular Crossfire Technique

One of the best ways to capture real sex while participating in it is with a "triangular crossfire". With this technique, you form a triangle with three cameras, one at each of the points of a "triangle". The diagram below will help to illustrate exactly what I mean.

This diagram is representative of a bedroom, which is where most amateur porn footage is going to be made. Since sex will most likely take place on the bed, we've arranged the cameras into a triangle that will capture the action from three angles as it

happens. One at the foot of the bed, and one on each side. Since most beds are set with the head against a wall, we don't have to worry about that angle. Once each camera is set to record, you won't need to adjust anything during the shoot but can effectively capture all of the action, as it happens.

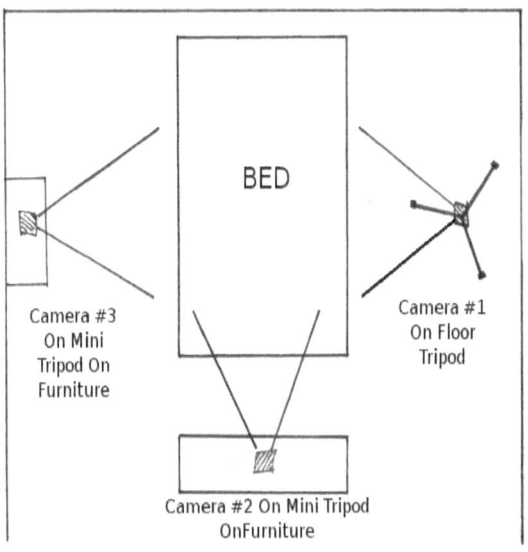

There's an artistic consideration that we should be aware of as well. Life, as we see and experience it, is three dimensional. However, video is a two dimensional artistic medium. One of the breakthrough artistic achievements of the Renaissance was actually the "rediscovery" of three dimensional sculpture. Basically, they began to create 3D statues that a viewer would need to walk

around to fully see, just like the Romans had centuries before. When one studies these pieces, they walk around them and consider them from all angles. For the proceeding thousand years, sculpture had only been limited, two dimensional relief style work. This 360° sculpture is called "sculpture in the round".

The triangular crossfire pattern allows people wishing to make better amateur porn the ability to capture three dimensional reality, even with a two dimensional media. This like the "sculpture in the round" creates a more realistic, true to life recording. I'll explain.

Imagine for a moment that one person is giving a blowjob to another in a room with a triangular crossfire setup in it. If you only had one camera, you would only be able to capture this from the single 90° perspective of that one camera. However, with three cameras rolling, you can effectively captures this action from a 270° perspective that you can easily splice together in post production.

You'll be able to show the same sex act from different perspectives. First off, this will involve the viewer in the act much more. You can make is seem that they are in the room, walking around and

watching as things unfold. This ability to show the same moments in time from varying angles will help to suggest the three dimensional reality that I've already alluded to.

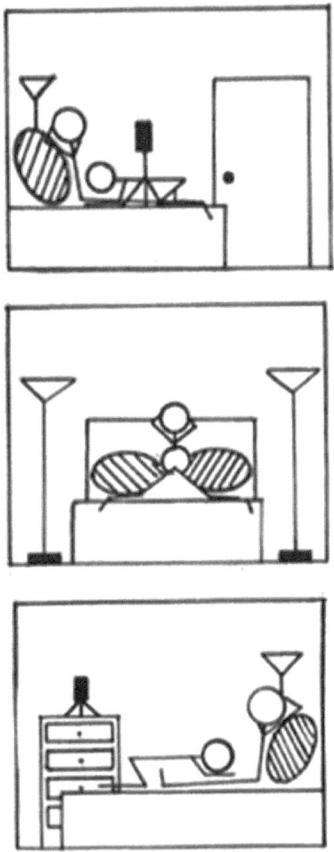

The same scene, captured from three different angles offers you creative options, the ability to pick the best shot, and less risk of missing something really good.

There are other positive benefits offered by this three camera technique as well.

The truth is that sometimes, a sex act looks a lot better from one angle than another. With one camera, something really sexy may have happened, but you might not have caught it from the right angle. You missed it because, simply put, one camera can only be in one place at a time. Trust me, when you realize that in post production, and conclude your camera was in the wrong place, your day will go downhill fast.

This is not the case with the "in the round" recording ability offered by three cameras. The three cameras are covering every angle. What one or two miss, the third will usually pick up. Think back to that blowjob scene I used as an example before. What if the woman's hair has fallen out of a pony tail and is covering up the actual blowjob part? With one camera, you might not realize that the camera view is blocked until it's all over and done with. With three, however, you're OK. You'll still most likely get good footage from the other two.

However, another possibility in this situation is that you use the footage from the camera with the blocked view to tease the viewer. You could

occasionally slip in more explicit and revealing footage from the other two cameras to heighten arousal. Tease and conceal, and slowly reveal. The important part, again, is more cameras offer more options in post and for the finished product.

Think of this setup as another insurance policy that helps you avoid missing out on great shots and allows you to create more engaging footage.

Now you might be thinking that a setup like this is going to break the bank. I mean, three cameras are expensive right? No! This is the absolute opposite of what's true. Thanks to the miracles of modern technology, cameras have done nothing but get smaller, cheaper and better. What would have cost as much as an imported Italian sports car in the 1980s costs a few hundred dollars at most these days. Now I don't mean that these will be absolute, top of the line, professional video cameras. They won't be. But they will be more than enough to do the job for any budding amateur porn artist.

Setting Up Your Lights

No matter what lights you're using, you need to make sure that they're set up correctly, and setting up your lights correctly is the step that follows camera placement. Setting up your lights isn't

terribly hard either, but there are a few common mistakes to avoid, and a few things you need to keep in mind.

One common mistake I see a lot is video that is shot with the light sources in the the camera's field of view. Usually it's something like a household light on a bedside table or maybe even the overhead fixtures. This causes all kinds of problems and that can be easily avoided.

Cameras these days do a lot of thinking. There are computer chips and integrated circuits in them that measure light and calculate camera settings based on measurements. Usually, they're pretty good. However, one example of cameras getting "confused" is when a camera is asked to record a light source. Basically what happens is the camera is flooded with light. In fact, it's too much light for the camera to handle. To deal with this, the camera adjusts exposure settings (don't worry about what these are yet) internally and actually darkens what's being recorded. What would be a great shot if the light source was just out of the camera's field of view is turned into an extremely dark, underexposed, badly lit piece of video where you can't see anything.

If you don't believe me, all you need to do is take a

camera, any digital camera will do, and point it at a light source. Just watch what happens. The shot will immediately darken. Now, take the camera and move it just a little to move the light source out of the frame. What happens? The shot immediately returns to "normal". It looks great and it's well lit.

So where do you put the lights?

That's an easy one. What you're looking for here is a compromise. Put the lights as close to where you'll be recording where they will be out of the camera's view. Decide where you're putting your camera. Then place the lights just outside of the shot. Obviously, this gets a little trickier with more than one camera, but by using angles, camera perspective and camera height, you can make this work.

Along with making sure that your lights are out of the shot, you want to make sure that your lighting is balanced.

If you put just one light source on a subject in front of a camera, you create a problem. Shadows get thrown. We want to avoid this. Shadows are unattractive. Shadows can be distracting. Shadows show the viewer that there's some sort of staging going on and they help to undo that natural,

amateur, spontaneous feel we're looking for. All of these are to be avoided.

Instead of using just one light that will create those unwelcome shadows, you always want to make sure that you have two light sources, at least. This will create the balance that we're looking for. What that means is that the two lights cancel out the shadows that are created. The end result is a well lit, natural looking scene.

Beyond just using two lights, you want to make sure that the lights are of equal wattage rating and are of the same type. Never use one fluorescent and one incandescent light bulb. If those are all you have, go to the store and get more bulbs. Mixed bulbs just confuse the camera from the different types of light that are emitted. Use the same light bulbs and use the same wattage. It's a simple rule that will save you a lot of trouble.

Lastly, I like to keep my lights at an equal distance from what I'm recording. This will ensure that equal amounts of light are hitting your subjects from all sides. If one light is twice as far from the subjects as the other, that one will be less powerful and shadows will creep right back in.

What I like to do is put the lights on an imaginary

line that runs perpendicular to the camera if I'm shooting with only one. If I'm shooting with multiple camera, putting a light in each corner of the room will create an all around balanced setup, plus, with the lights in the corner, it's pretty easy to make sure there are no shadows in the shot.

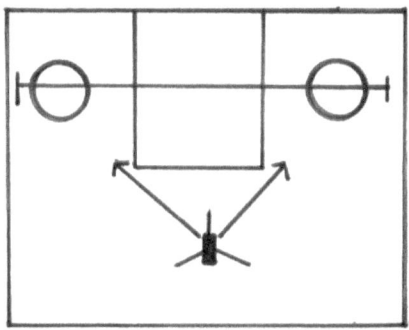

If you are shooting with one camera, place your light sources (circles) on an imaginary line that runs perpendicular to the line of sight of the camera. This will light your subjects well and cancel out shadows.

If you are using the three camera method, place a light

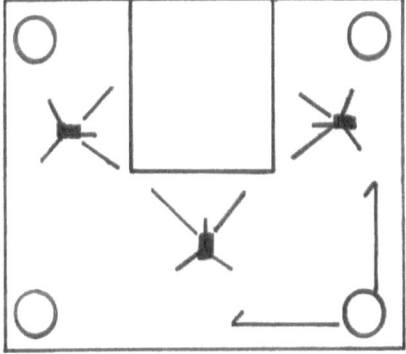

source (circle) in each corner of the room. This will create a well lit room and will cancel out shadows for all three cameras.

Make Sure The Cameras Are In The Landscape Orientation

To me, this seems like something I shouldn't even have to write about. But, from what I've seen out there, I do.

Since the frame, that is, the area seen and recorded by a camera almost always has one longer side, there are two ways to shoot footage and still pictures. The first type is landscape. Landscape shooting involves the longest side of the frame being horizontal. Like this:

```
Landscape Orientation
```

Shooting in "portrait style" is when you have the

longer side of the frame in a vertical position. Like this:

```
┌─────────────────────┐
│                     │
│                     │
│      Portrait       │
│     Orientation     │
│                     │
│                     │
│                     │
└─────────────────────┘
```

Now, since almost every TV, standard or high definition, and computer monitor in the world is configured for landscape video imagery, you would think that everyone would just shoot in landscape. But, no. They don't.

Why not?

It's because of smartphones. Smartphones, like camera frames, usually have one longer side and it just so happens that this longer side, usually corresponds to the longer side of the frame for the

phones video camera. People like to hold smartphones in a "portrait" style way that results in "portrait" style video. This, in the end, results in video that wastes most of the television's display, forces the imagery to be smaller than it needs to be and results in poorly done amateur porn.

If you want to use your smartphone as part of the the camera setup when making your amateur porn, please go right ahead. However, if you do, make sure that you have it positioned in a "landscape" fashion. That goes for all your other cameras too.

Real video artists, whether shooting porn or not, should always do so in landscape. Never in portrait.

Period.

Set Your White Balance

Have you ever watched a video and the color seemed a little off? Maybe it was a little too orange or a little too blue. This was because the white balance, or color balance, wasn't set properly and the camera distorted the colors of the image as it recorded them.

Here's why that happens.

The sun puts out light. An incandescent light bulb

puts out light. A fluorescent light bulb puts out light. A camera flash puts out light. None of them, however, put out the exact same light. There are subtle differences in the light. I've already mentioned how an incandescent light bulb puts out a lot of red light and a fluorescent light puts out a lot of blue. The sun puts out what we would call "natural" light.

You probably don't even notice the difference. This is because your eye is an absolutely wonderfully designed piece of optical machinery. It's the refinement of billions of years of development and represents the the cutting edge in bio-optical technology. Your eyes actually adjust to the differences in light and adjust to make colors remain consistent. It's remarkable if you actually think about it.

For all the advances that have been made in digital camera technology, cameras are nowhere near as good as your eye. Yes, they can see in better detail, but they have trouble with things like color. Cameras will make adjustments to color and they can sometimes get it wrong. That's where white balancing comes in.

When you "white balance" a camera, you tell it what it should consider as "true" white. With this

standard in mind, the camera can then make educated decisions about how to render other colors. I'm massively oversimplifying this, but to make better amateur porn, this level of information will do.

When you decide on cameras with which to film your porn, you need to get your hands on the manuals. This can usually be done on the manufacturer's website. You'll just need the model number, which should be on the camera. With the manuals in hand, look up "white balancing". There you'll find the specific information you need for your model. Usually, there will be an "outdoor light" setting, and "indoor light setting", an "auto white balance" setting and a "manual" or "button" setting that runs a calibration procedure each time you activate it.

You might be tempted to just throw it on auto white balance and call it good, but I would caution against that. In my personal experience, auto white balancing is usually a little less reliable than you might like. Again, in my opinion, there's a good chance you could wind up with something a little too red or a little too blue.

Outdoor/Indoor are usually better than auto and can make life easier, however, the manual/button is

usually the one you're going to want to use to get the best color balance. It will give you color balance that is specifically tailored to your current lighting.

With this setting, you hold the camera on something white, like a piece of printer paper, for 10-15 seconds (consult your manual for the actual procedure). Make sure to fill the viewing frame with the white object. There's usually a button that needs to be pushed to start the calibration once you have everything set up. Wait for the message that says the camera is done. Doing this will make the colors a lot better in the finished product.

Anyway you cut it, no matter which setting you find gives you the best true colors, you need to make sure to check the white balancing setting on your camera before you shoot, but after your lights are set up. Get in the habit now, in the beginning and make it part of the routine 100% of the time.

Choose & Set Your Perspectives

We've talked about how the triangular crossfire camera setup can be used by the amateur porn producer to capture sex in a 270° field of view. This allows for the recording of three dimensional sex in a way that does not lose the three dimensional feel.

However, there are other advantages to be had by using multiple, inexpensive cameras in this way.

Beyond just increasing the field of view of your recording, you also have the ability to take advantage of multiple perspectives. Perspective is another important concept in videography that's often ignored by the amateur producer. Usually, people point a camera at a bed and just call it good, but we can take it far beyond that.

First, let's define perspective before we dive into a discussion of how you can use it in creating your amateur porn art.

Perspective is, in a nutshell, how we look at things. More specifically, in videography, it's how we look at what we're recording. There are more ways to look at something than you might be aware of. Let's jump out of the bedroom and the realm of amateur porn for just a second and look at an easy example.

I want you to imagine a flower growing out of a flower bed on the ground. Flowers are common, everyday items in our world. People do like to stop and smell them and enjoy their color from time to time. For the most part, however, flowers are so commonplace that we really pay little attention to

them. However, they have a lot to teach us about perspective.

The most common way to encounter a flower in a bed is to walk by and look down on it. People look down from five feet or so and take in the flower. However, there are other ways. What if you lay down on the ground and looked up at the flower? You would see things in a whole different light. You would see the underside of the flower. You would see different details. You would see different structures that you would never have seen simply by standing next to the flower and looking down. Another, whole different perspective could be found by getting down and looking at the flower "eye to eye".

A single flower can be looked at many different ways, as these example photos show. Think about how many ways you can look at people having sex with a little creativity.

Long story short, there are many, many different ways to look at the world and you, as the director, get to choose which ones you record with your cameras. This gives you a lot of creative license as well as options to try.

This applies to filming amateur porn as much as it does to any creative effort behind the lens of a camera. Let's look at an example that's a little more relevant to this book's subject.

Imagine you have three cameras and you're setting up a triangular crossfire set like I've described. You

could of course, put all of the cameras on the same level, pointing at the bed. Pretty vanilla. This is a basic setup and there's nothing wrong with it. In fact, there's some argument to be made that this is how you should start in your amateur porn career. It's basic, simple, and will capture all of the action you want. Great.

However, you could also put the cameras on different angles, at different heights. You could put one low to the ground, for example on a bedside table. These tables are usually level with the bed or even slightly below the surface of the bed. This will create intimate level, like the viewer is in the bed with you watching things unfold. It might, depending on the level of the table, produce an up angle. This would give the viewer the sensation that they're looking up at the action. This angle is great for capturing those close up views such as during doggystyle when you want to record the very most intimate visual details.

That's only one of the cameras. If you place that one on a bedside table, or maybe an ottoman, you could call that your "low" camera.

You could place a second camera at head height on a tripod as well. This perspective would be looking at a downward angle at most beds in the world.

This perspective would offer the viewer footage as though they had just walked in and caught you and your lover in the act. This offers a totally different and less intimate view of the action in your bedroom than the "low" camera. The camera is recording the same action but in a way that conveys totally different perceptions, feelings and connotations to the viewer. You could call this the "mid" camera.

If we have "low" and "mid" cameras, you can be certain that we'll have a "high" camera. With the high camera, you want to go as high as possible. A tall tripod can work for this, but more often than not you're going to find yourself using a micro tripod with flexible legs on a high piece of furniture. I'm thinking a bookshelf again. You could also use a flexible leg tripod and hang a camera from a light fixture, weight permitting. This ceiling, looking down shot, would be the ultimate "high" camera.

From eight feet or even higher, this camera will be looking down on everything. This is an unnatural perspective and not one that most people would ever view sex from. I mean to see things at that angle, you would have to be hiding in the corner like a spider monkey. Images that allow us to look at commonplace sights, like sex, from unnatural,

uncommon perspectives are always interesting. Note that I said interesting. They're not automatically good. That will be your decision to make as the artist.

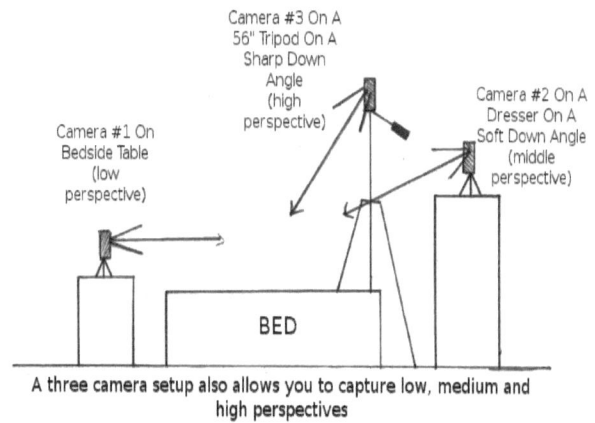

A three camera setup also allows you to capture low, medium and high perspectives

How would you use this perspective? One thing that you could try would be to wash all the color out of the footage in post production. This technique could be used to create the feel that the viewer is watching what's happening through a security camera or some other hidden recorder. Remember how people want to know what's happening in other people's bedrooms? This is an artful way to

heighten the excitement of the viewer without having to change the nature of the sex at all or lose that "amatuer" feel. Perspective alone will give the viewer the feeling that they're seeing something that they shouldn't be. You're tricking their mind and at the same you're time heightening their excitement through the manipulation of perspective alone.

I really want to nail down this concept and make sure you understand and feel empowered to use different perspectives in your art. Let's look at one more example before we move on.

Imagine a man is standing and a woman is giving him a blowjob as shown in this diagram:

You could set up one camera, stand in front of it and record the action like this:

That would be basic, very fun to watch and interesting on its own. However, when a blowjob is happening, there is often more than just one thing going on that might be fun to watch. There's the side view of the cock going into the mouth. However, we could also view this action from above in a point of view (POV) shot. This would instill the viewer with the feeling that they are actually getting the blowjob.

But wait! There's still more. What if the woman is naked and on her knees? Well, there's a lot going on there that we can't see with just a POV shot or a standard side blowjob. What if we mounted a camera on a small tripod and placed it immediately behind her, on the ground, looking up. This would capture the blowjob from behind her. We could see what's happening between her legs, the curve of her back, her ass or the motion of her head and body. Maybe she's playing with herself. Even if she isn't, it offers a whole new, tantalizing view. In this imaginary shot, we see lots of her, but the blowjob itself is enticingly obscured. Her face is hidden along with her identity. We know what's happening, but we can't actually see it. But we can't look away because of what's being shown in it's place.

It's quite impossible, without mirrors for a man to get a blowjob and see this perspective. That makes this a less common and more interesting way to film a blowjob. As amateur porn artists, that should interest us very much.

But, I'm not done yet.

What if we put a camera right on the ground, looking straight up looking directly up at the couple mid oral coitus? Like this:

This is another, not often experienced perspective that creates a whole new, fun way to look at a blowjob. We see the oral in and out, but we can see all sorts of other usually hidden action. Even the underside of balls can be interesting when we look

at them in a way that we're not accustomed to. Remember, amateur porn is part spectacle.

When you're producing your amateur porn, feel free to push yourself to look at the world, in your bedroom, in ways other than you normally would. Remember that there are many, many ways to look at a flower. Don't feel bound by "normal" or "traditional". Feel free to experiment, dabble, play and explore how you look at and record your sexual antics. You might, if you're lucky, come up with a whole new way to look at sex, and the raw passion of the amateur bedroom.

Set The Framing

When shooting amateur porn in your own bedroom, you'll have to set the framing of one, or maybe even three cameras, before the shoot begins and then just let them run. This is a big decision. But before we talk about how to do it correctly, you need to know what framing is.

So just what is framing?

Video cameras originally recorded on film, just like photographs. These pictures were developed on a long piece of acetate film to make a movie reel. A movie was nothing more than a lot of still

photographs moving in quick succession. Each individual still picture was referred to as a "frame". The days of frames and film, as far as amateur porn is concerned, are over. Everything is digital now . The phrase "frame" that evolved then, however, is still used by photographers and videographers the world over.

For the rest of this book, the word "frame" will be used to describe the field of view of a camera. "Framing", will be used to describe how you, as the artist filmmaker, decide to orient the scene you're recording within that field of view. Those are seemingly complicated definitions. It's actually pretty simple. Framing is just how you decide to record what's happening in front of your cameras.

You adjust the framing by zooming in and out with your cameras' lenses.

Let's look at an example that'll help make things crystal clear. In your mind's eye, I want you to picture two people having doggystyle sex. They're doing it in front of you and you're the camera operator. How do you zoom the camera's lens in or out to record what you are seeing? What will work best?

One option that you might be tempted to use would

be to zoom out as far as the camera will go to capture as much as possible within the frame of the camera. Just take a shotgun approach to it. This might just work. You can leave it just like this and let the camera run, and given the wide field of view, even if the people that are having sex get up, move around, stand up, they'll still be in frame. You don't need to change anything and you can just let the camera record.

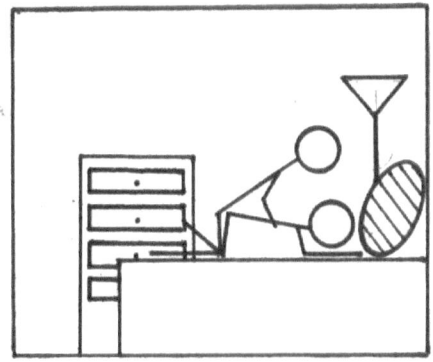

An example of wide framing.

That will work. You won't miss anything, but there are some downsides. If you look at the drawing above, and you look at the area above the couple on the bed, you'll notice a lot of white space. This isn't an accident. When you zoom out as far as possible and set the frame as wide as you can, there's a good chance that what you're recording, won't fill up the

frame. This is aesthetically unpleasing. The subjects look too small. There's a lot of visual stimuli in the frame that isn't sex. In amateur porn that's undesirable. Also, since you've zoomed out as far as the camera will go, the detail will be lower. You're wasting frame by giving your viewer stuff to look at that isn't sex and you are cheating them out of detail.

I think we can do better. What if we go to the opposite end of the spectrum and zoom in on the action and focus on it?

An example of extremely tight framing.

When you zoom in really tightly on the action, you get a lot more detail. Add to that the fact that you fill the frame with a lot more action. There's no

wasted frame here. You have crammed in as much sex as you can and it's in really high detail. Better right?

But, there are still drawbacks to this framing style as well. Since you've zoomed in as tightly as you can go, you now cannot get all of the lovers in frame. By looking at the example above, you can see that their heads have been cut off. You do have all of the hot and naughty sex in there, but now you're missing out on all the facial expressions that might be happening at the same time, as well as any kissing, nuzzling or nibbling.

There's a lot more to sex than just some close ups of fucking. Remember, we're trying to capture more than just mechanical sex with amateur porn. We're trying to capture emotions, pleasure, reactions and reality. That stuff, at least how we as humans communicate that stuff, does not happen below the waist. It happens above the waist, actually above the neck. By zooming in on just the mechanics, we're giving up a lot of opportunity to capture the reality and the feel of the sex that's happening in front of our cameras.

I've been a little leading up to this point. I've shown you the two extremes in framing as a way to, pun intended, frame our discussion.

What you really want is a compromise. You want to zoom in as much as is reasonable on two (or more lovers) but not so much that you're leaving parts of them out of frame. Finding middle ground between the two extremes is the key. You want to get in tight enough to not waste frame or lose detail, but not so tight that you miss out on important parts of the sex.

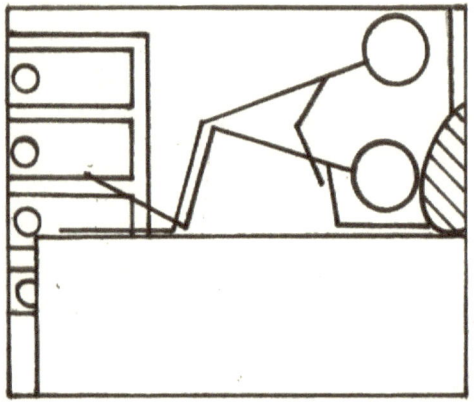

The framing here is just right. Not too wide. Not too tight.

A well framed piece of adult film would look something like the image above. In this fictitious example, all of the couple is in frame. We won't miss any facial expressions, tantalizing eye contact or orgasmic exclamations. However, at the same time you'll see that there is considerably less white

space than in the first framing example diagram. This way we're maximizing detail and making the couple as large on camera as possible. This means more detail and the viewer will feel closer to and more a part of what they are watching.

Whenever you're shooting, try to operate the cameras to find just this sort of balance in framing. Fill the frame, but don't get in so tight on your subject that you're losing part of what you should be recording.

Marking The Frame

With no one there behind the cameras to fix thing if you and your lover should happen to roll out of frame, you have a small problem that can be easily avoided. Don't laugh. If the sex is good this can happen very easily for two distracted people. It's happened to me and then, lo and behold, there are just a couple of legs in frame and the cameras are missing all the great sex. It's something to laugh about now, but I missed out on some really good footage.

This whole headache can be avoided by "marking the frame".

Basically, this technique involves setting some

boundaries that you and your lover can easily notice. If you stray out of these, you'll know that you're out of frame and can make quick, seamless adjustments.

One step that you should take is to set the edge of the frame on a wall if possible. This shouldn't present a challenge as long as you're shooting indoors. For example, set the camera perpendicular to the long axis of the bed and use the headboard as the edge of the frame. If you do this, you have one well set boundary and you only need to worry about the other side. Marking that boundary is easy enough too.

The simplest way to do this is to use the other end of the bed. You can set the frame to encompass the whole bed with the headboard as one boundary and the foot of the bed as the other. This will create a bit of a wide frame with more empty space than you want, but it's a good place to start while you're getting comfortable with a camera in your bedroom as well as staying in frame

If you want a tighter frame you can put a pillow or some other innocuous marker on the bed. That way the pillow will denote the edge, but it will seem innocent to the viewer and they won't be distracted.

If you're worried about the height of the frame, say you want to stand up on the bed or do some doggystyle or standing sex, mark the wall with a piece of masking tape. This won't hurt the wall at all, but will provide a quick visual cue to you and your co-stars. I would suggest putting the tape just above the top of the frame or there will be a weird white line going across the wall of your set.

If you're having sex somewhere other than a bedroom, like a living room, and you need some frame reminders, you can also put the masking tape on the floor. Again, put it just out of frame, but again, it will serve as a nice easy reminder of the borders until you get more comfortable with sex in front of a camera. Again, if you don't have masking tape, use pillows or something else that will serve as a quick visual cue of where the frame ends.

Using this little technique, especially when you first start your camera in the bedroom fun, will save you some headaches when you go to edit.

Get Everything You Need Close By

Once the cameras start rolling, you should keep the action going. In radio, you want to avoid dead air

and when filming sex, you want as little down time as possible. Your viewer should not have to wait while you get up and wander off camera to find that big pink double dildo you need. The big pink double dildo should be right there next to you ahead of time. You should only have to roll over and grab it.

Try to make sure that you have everything you need before you start your scene. Gather up all your toys, gags, lubes, dildos, and such beforehand and place them somewhere close. If you don't want them on camera right away, maybe you want to surprise the viewer later with them, keep them out of frame. This can easily be done by placing them behind a couch or on the floor next to the bed or just beyond the frame marker. With proper, thought out framing, it's easy to create a part of the room that's obscured from view, yet still within reach.

I'll give you a little tip here. Put your toys on a towel before you put them on the floor. Don't put them on the floor directly. Nothing ruins an amateur porn movie faster than one of the actors stopping to pick an errant dust bunny off of a silicone dildo. Silicone is sticky by nature. Like in so many areas of life, cleanliness counts here.

A little organization and a little forethought into

what you need will make the finished video much better. I promise.

Get A Space Heater

It's no secret that the clothes we wear keep us warm. When we're nude, we tend to get a chill much more easily. This isn't usually an issue during sex, because sex often happens in a bed, under covers, at least until we all warm up. When you're shooting your first amateur porn, this will not be the case. You'll be out and exposed.

There's also the nervousness factor. Admit to it or don't, but there is a good chance that when making your first porn, you or your partner will be a little more nervous than usual. There's nothing wrong with this at all. It'll pass, but there is a physiological effect that we, as producers, should take into consideration. When a human is nervous, blood tends away from the skin and more to the center of the body where the organs are. This is thought to be a defense mechanism. However, it can make skin cold and clammy and can make people unable to warm up. This is why paramedics will wrap people who are in shock in a blanket.

Now you could just turn on the heat in your house. That might help, but central heating tends to be

slow to spread throughout the house. Plus, if you're only in the bedroom and only want the bedroom to get up to a nice comfortable, 80° Farenheit, it's a waste of energy to use central heating.

Instead, plan ahead (there's a theme in this chapter) and go buy an inexpensive ceramic space heater. These little babies can make one room in the house very warm, very fast. If you or your lover get cold, a few minutes from one of these things will fix everything in a hurry. If you ever get to this point, again, you'll be glad you planned ahead. Cold actors make bad amateur porn.

There Should Always Be Drinks Of Some Kind

If you and your lover are over the legal drinking age where you live, you should consider having a few drinks handy when you're setting up your scene. Splitting a bottle of wine or relaxing with a gin and tonic to get the mood just right, before the cameras start, is a great way to mellow everyone out. The first time in front of a video camera, especially while you're having sex can be tense. It's like a first date, a first kiss and a first time all rolled into one. Tensions and awkward moments can easily pop up. Anything you can do to defuse these and encourage participants to shed their inhibitions will make your scene better.

In addition to some adult beverages, you want to make sure that there are some bottles of water handy or a nice, icy pitcher. It can get hot on an amateur porn shoot and people get thirsty. You'll want water, I promise. Think ahead and make sure there is something cool to drink in a place you can reach for without having to leave the frame.

Check Everything Twice

As silly as it sounds, once you have everything set up, make sure you check all the little details again and make sure everything is really, really set up the way you want it before you start the fucking.

I want to tell you a personal story of failure.

Still photography is a hobby of mine too. A long time ago, I went out on a shoot. It was early and I woke up before sunrise to go and get some great morning pictures. I would have too, except for one minor detail. I started shooting before the coffee had kicked in. My mind was still half asleep and I accidentally set my lens to manual focus instead of auto-focus. I'm accustomed to shooting in auto focus, especially for landscapes, and somehow the switch had been accidentally flipped.

Well, I didn't check off all the little details I needed

to. It was just a stupid little mistake anyone of us could make when we're tired. I'm not perfect. I was sloppy and as a result, I lost a bunch, of what would have been very good shots. They're gone forever.

Now these were shots of a sunrise. It wasn't the end of the world, sunrises happen every day. But remember back to my example of you hooking up with two sorority girls in Cancun on spring break. That doesn't happen every day. If you find out that your video is ruined because, for example, you forgot to take off the lens cap, and you lose forever the video of those coeds, you'll be devastated. Why wouldn't you be? I certainly would be.

Save yourself the headache and just make sure that before every shoot, you go through and check all the different features on your camera that we've talked about. Make sure everything is set the way you want it. Make sure that the lens cap is off. Make sure the framing is good. Look through the lens. Do you like what you see? Is the white balancing good? Etc. Etc. Etc.

Getting in the habit of double checking the details before you call "action" will save you a lot of heartache later. I learned that lesson that chilly morning. I've never forgotten it. Hopefully you just learned it and you didn't even have to get up

early to do it.

Now that's it for this chapter and for the technical discussion in this book. In the next chapter, we'll talk about a whole smattering of artful tips to make your porno more appealing, sexier, more watchable and enjoyable for your viewer. Think of this chapter as the foundation for your amateur porn career. The next chapter will be all about design and setting your creativity free.

Chapter 4
Artful Hodgepodge

You'll find that t\his chapter has no theme at all.

If you look up the word "hodgepodge" in the dictionary, you'll find it's a word that means a bunch of unrelated things that are put together. That's exactly what this chapter is. It's a bunch of unrelated tips on how to make better amateur porn. Not many of them have anything to do with each other, but in the end, I felt that they all needed to be included, or I wasn't doing my job of author very well.

I hope you like them and I hope they help you to make better, more watchable and more artful movies in your bedroom.

Amateur Porn Can Be A Solo Affair Too

Up until now, in this book, anytime I've referred to action in front of a camera, I've referred to "you and your partner(s)". There's always been the assumption that you and someone else would be playing in front of the recording camera.

I want to take a moment to mention that it's completely OK to record yourself in solo sexual performances as well.

There are many reasons that someone would want to and would draw pleasure from recording

themselves during masturbation. The desires to be watched and to perform are no less strong when people are between relationships. You could easily have fun with a solo sexual recording by using it as an enticement to your lover. Sending it to them while they're at work is cliche, but also a great way to invite them into some fun when work is done. Think of it as an invitation to join you in front of the cameras. Of course, there's always the publication of the anonymous video and the pleasure in knowing that people are watching it, wondering who you are. The dirty secret is the best kind of secret.

Since this chapter is all about artistic considerations and ways to make your porn better, I think it only natural to take a few minutes to discuss the artistic value of solo amateur porn. Is it still art?

Recall back, when we talked about art as a way of capturing rarefied moments of the human soul. Is this still true if you're alone in front of a camera? Of course it is. When we masturbate, we take time to focus solely on ourselves in a completely hedonistic, selfish way. We're focused solely on ourselves and no one else, and the pleasure we experience is no less real and no less worthy of consideration. The fact that by making the

recording to share, we allow others into a deeply private world that only we inhabit, and only for scant few moments at a time, alone makes it art. Masturbation is all about what we do when we know no one is looking. Think about it. A solo sexual recording creates a window into a world that, by definition, we can only know alone, and then allows us to share it. How better of a way to showcase a piece of your soul can you imagine? And, after all, isn't that what art is supposed to do?

So when you're done reading this book, for whatever reason you choose, don't be afraid to roll the cameras, even if it's just you.

Observer Effects

Some of the first pictures, from when cameras were invented, are what we would call X-rated today. That says a lot about people. We like to be watched. We like to show off. We enjoy it. There's something in our nature. I won't try to explain it. That's something for psychologists to wrestle over. For our purposes, it will suffice to just say it's there.

This can also cause a problem for lovers intent on making real amateur porn. People, under observation, tend to behave differently than they would if they weren't being watched. In science,

this is called "observer effects". By observing a knowing subject, scientists can negatively alter the behavior of that subject.

This is no less true in amateur porn. A lot of the time when lovers first appear in front of the camera, there's a noticeable change in their behavior. This usually takes on one of two forms. The first is stiffness and awkwardness. The other is showing off. Either of these, one would say, are undesirable.

Remember that good amateur porn captures real people having real sex, really enjoying themselves. The key word there is "real". Just like a scientist observing a spider monkey, the viewers of amateur porn want to see what really happens when no one is looking. We usually don't want to see what the subject thinks we want to see. If people are showing off or tense, the reality goes right out the window and the quality of the video goes down fast.

One suggestion I can make to help combat this is to try really hard to ignore the cameras the first few times you shoot. That is, at least until you and your lovers get used to the idea of being watched by them. Do what scientists do when they want to see what that spider monkey is really up to – hide the cameras. "Out of sight, out of mind" really works. I've done it. If people can't see the cameras or

they're not right there, in their face, they'll relax, get into things, start to enjoy themselves and they'll behave more naturally. The end result will be a much better recording, and a much better sexual experience as well. Sex sucks when people are nervous and tense. No one is going to have an orgasm like that.

Once you and your lover have a few movies under your belt and you're fast building up your secret, amateur porn archive, you can bring the cameras out and get more sophisticated. At that point, you'll all be much more used to them and be able to act much more naturally in front of them.

By then, in fact, I'll be surprised if you even notice they're there.

Start Simple

I'm as guilty of violating this rule as anybody. When something new comes into my life, like a fun, new amateur porn hobby, I love to dive right in. I really get into things. It's a failing of sorts.

When you first start out in amateur porn, I would counsel you to start and stay simple for a while. Keep your equipment simple. Get your hands on some inexpensive cameras and tripods and have

some fun. Avoid buying big expensive lights, the latest video editing software and massive hard drives to hold your creations. Start basic. Keep your costs low until you know you and your partner really enjoy this. Try it out first. Dip your toe in the lake. Don't dive in. If you do and the two (or more) of you have fun and want to make this a regular part of your sex life (nothing wrong with that), then you can make other investments in equipment and dive into the lake. By then you'll know the water's warm.

By following this advice, you won't waste a bunch of money buying equipment only to find out that you don't enjoy having sex on camera as much as you thought you would. Your risk is minimal this way.

Additionally, this same "keep it simple" philosophy should apply to what you shoot as much as what you shoot it with. Keep the sex simple too. Have sex like you and your partner(s) normally do. Don't dress it up. Don't make it into some big, scripted production that you think will look awesome on film. For now, have the sex you normally have, just in front of a camera.

Undress On Camera

Most sexual encounters start with all of the participants' clothes on. However, frequently in amateur porn, the movies begin with the participants already undressed. They get right to business and the viewer feels like the walked in on something that's already started, and that they missed out on something.

Some of the most fun that you can have in the bedroom is during the frenzied, passionate strip down with your lover. Buttons pop off. Maybe panties get ripped. You and your lover are in such a charged state that you tear each other open like a package on Christmas morning. It's hot. It's sexy. It's magical. It's also a lot of fun to watch and skipping it can detract from the quality of the finished work. Something is missing. The narrative is incomplete.

Long story short, don't be in a rush to get naked on camera. Like I've said so many times throughout this work, let the sex flow naturally. Tell the story from beginning to end and let the arc take the shape that it will. Start in a clothed state just like most sexual encounters do.

Plus, you can always cut it out in post production if

you decide that you don't like it after all. You just can't add it in if you don't film it in the first place.

Don't Forget The Foreplay

A lot of the time when a couple first starts filming their bedroom antics, they seem to forget all about foreplay too. They just seem to leap into the actual sex. Amateur porn starts off balls deep way too often. This is another one of those things that happen when people know they're being watched. It's also a great example to illustrate why it's best to ignore the cameras. Try to have sex just like you normally would. You would normally have foreplay in your lovemaking, I hope. Why not on camera?

Ignoring the foreplay, skipping the foreplay or editing out the foreplay are all huge mistake to the amateur porn producer can make. Let's review. Amateur porn is special because it captures real people, having real sex and experiencing real pleasure. Remember the three "Reals". I've talked about them consistently throughout this book. Real sex. Real people. Real pleasure. In essence it's about two or more people connecting on a very real, very personal level and we're getting to watch that. Sex is much more than just cocks and pussies. It's emotion, connection, passion, intensity, desire, lust

and romance. So many of these abstract qualities, as far as film is concerned, are created and demonstrated during foreplay. When we see people kissing, breathing deeply, laughing as they undress each other, playing, smiling and generally enjoying themselves as they surrender to one another, we feel more drawn into the sexual act. We can see and feel the genuineness of the scene. Believing that the people we're watching are making love because of an authentic desire to do so is much easier at that point.

Again, just because cameras are rolling is no reason to alter the sex you and your partners have in anyway. That applies to foreplay as much as it does to anything else.

No Storyboarding, No Scripting & No Directing

Storyboarding is a technique used in videography, whereby during the planning process, scenes that the director wants to capture are literally drawn out ahead of time. These drawings, show the actual image that should be recorded. This is an incredibly common technique that's frequently used – even in professional porn.

Now that you know what "storyboarding" is, I want you to forget all about it. You should never, ever

incorporate storyboarding into your amateur porn productions. In good amateur porn, you should never worry about how the lovemaking will unfold. Remember, real amateur porn is about real people, having real sex for real pleasure. Real sex never follows a script.

Storyboarding will completely undo what you're trying to create. The truth is, storyboarding will give the action in your movie a fake, forced, artificial quality that will be perceptible to the viewer – even if it's just you. I've seen plenty of storyboarded porn done by amateurs. It's not a lot of fun. The people pause, talk and discuss how they should keep fucking and they include that in the final product! It's terrible! It's contrived at that point and the "real" quality has completely been destroyed. These people are muddling their way through what they think would look hot or sexy without realizing that the "realness" is what makes it hot and sexy. Remember, the viewers of amateur porn wants to feel like they are looking through your bedroom window without your knowledge. They want to see what really happens in there, not an artificial presentation of what you think would look good or what they might like.

Instead of storyboarding, since you'll not be able to

pull it off effectively and it will make your video suck; fuck naturally, like you normally do. Record it from several angles, like we've talked about. Then, when you're done and you and your lovers have rehydrated, showered and rested, do some video editing.

Right there with forgetting about storyboarding, make sure you aren't directing. Don't try to control events as they unfold. Let it happen and let the cameras capture events as they unfold. Remember to keep it natural and fluid. If you try to direct, the resulting footage will be choppy, seem faked (which it will be) and will not wind up being very sexy or very watchable anyway. Just don't.

The same goes for scripting. Forget it. Put your typewriter away. There are no scripts in amateur porn!

Have real sex in front of your cameras. Focus on that instead.

Adding POV Perspective

Another dimension that you can choose to add into your amateur adult film is called POV perspective. POV stands for "Point Of View".

This technique can offer a really enjoyable

perspective if done properly. This allows the viewer to see the sex from the point of view of one of the participants. Instead of seeing it from the third person, witness perspective that a still camera offers, they see the sex first hand. This makes them feel like they're an intimate part of the action. This heightens intimacy, connection, and arousal and can suggest to the viewer that they, themselves are involved in the movie.

There's a lot to be gained from adding this perspective, but there are also some big pitfalls and challenges to be avoided.

The most obvious problem that arises is camera shake. To do POV shooting, you'll be hand holding the camera. This means that the camera will move each and every time your arm moves, even slightly. This can result in an erratic, jerky and distracting finished product. This shouldn't come as surprise. Holding a camera steady while you're simply standing is a challenge. Holding a camera steady while you're having sex is nearly impossible.

Rather than seek to eliminate camera shake, all we can really hope to do is minimize it. If you shoot in POV, you'll need to accept that fact.

One trick that can be used to help compensate for

this problem is for the camera operator to brace themselves. Here's what I mean. Imagine that you're eating some pussy. Obviously it's going to be impossible to eat pussy at the same time you're using a video camera. That just isn't going to work. So what you do is you hand off the camera to the woman whose pussy you're eating. She, most likely, will be lying on the bed. Now if she moves up a little and leans against the wall or headboard, she'll be braced and **relatively** still. This will dramatically reduce the camera shake and will offer a much better recording, and a better finished film.

This same technique can be used in any standing or seated position. Sex in a lounger or on a couch will be much more stable than say, doggystyle on a bed, because the camera operator can be seated with their back supported. If you're standing, say in a blowjob scene, lean against something. A wall or a bathroom stall door will work pretty well and will help to stabilize the camera. The camera will still move, but the movement will be greatly reduced. That's as good as it gets with POV shooting.

Positioning your self against a sturdy surface like a wall can help to reduce camera shake.

If you just have to use the POV technique in a setting that won't allow you to brace yourself against something for stability, you're not completely screwed. As an artist, though, you should understand that the less you brace yourself, the shakier, more distracting and less enjoyable

your footage will be.

If your camera is really small, you can always brace it against your chest. This will result in more shake than if you were braced against a wall. However, it will result in more stable footage than just holding the camera in front of you, just dangling in the air. Using this technique does restrict the camera's possible movements somewhat and that's helpful. However, if things get going really acrobatically and the camera is really just bouncing around, you should really just set it down and let the still cameras do the recording. A good amateur porn artist should know and admit their limits.

Another possibility, although a more expensive option, is to simply mount a camera on someone's head. Yes, I'm serious. There has been a lot of development in the "extreme camera" market in recent years and we'd be silly to ignore the options that these devices afford as far as amateur porn is concerned.

Extreme cameras are small, HD (1080, 16:9, 60fps), video cameras that can be mounted on someone's body allowing them to record, while using their whole body freely. That sentence, alone, should be more than enough to get your attention. They're designed for extreme sports enthusiasts to record

their shark diving, parachuting, mountain biking, etc. Originally, these were pretty expensive, but technology has advanced to the point that these cameras are relatively inexpensive (less than $400). Plus they record great footage and they're almost indestructible. If you have your heart set on adding the POV dimension into your amateur porn creation, you should seriously consider adding one of these to your toolbox.

Now, there's another consideration to adding a head mounted POV camera to your amateur fun. That camera will record some interesting, first person sex. However, any still cameras you have will record a person with a camera strapped to their head. This could be a bit distracting to any viewer and may detract from the film's aesthetic appeal as well as its "amateur" feel. In the end, you, the artist/producer will have to make the call on POV. Just keep that in mind.

Honestly, at times I really like POV footage. It can be a lot of fun and can really draw you into an amateur video creation. However, also in my opinion, it's more often bad than it's good. Most of the time your end result is footage that's jerky and distracting. Beyond that, when someone is holding a video camera to add POV perspective, they tend

to direct and the sex takes on that artificial, scripted quality. Remember, we want to avoid that at all costs.

The truth is that adding POV perspective is hard to do well. People just weren't meant to hold a camera and have free flowing, natural, realistic, pleasurable sex. It's just a fact of life.

As a bottom line, when you first start out, I'd strongly, strongly recommend that you stick to still cameras. Work with those first. They're easier to use and they're much more forgiving in terms of the final recording. Start with still cameras, get used to having sex on camera with those. Refine your video production techniques and skills with stills. Get good with those first and then, once you're more experienced, you can make a better informed decision about adding POV. That's my advice on that.

Please Gives Us More Than Balls & Ass

A lot of the time, the people who make amateur porn seem to be under the impression that there's an overpowering need to show a dick going in and out of something. Most of the time when this happens, the camera gets focused in on an extreme close up of the actual physical union that takes place during

sex, and then it just stays there.

To be frank, this is a problem. Now don't get me wrong, I like to get up close and personal at times. The details can be fun. Filming scenes that are often unseen by people having sex does offer some appeal. We've already talked about that. But I want you to think of this type of shot, the up close and personal with his scrotum shot, like you would garlic in the kitchen. A little bit goes a long way. A few seconds of up close and personal with a cock going into a pussy is fine. We'll all look. But when the seconds begin to tick by and I'm left staring at his wrinkly ball sac and the mystery froth that's beginning to form where his cock actually disappears inside her, I began to wonder what else is going on in the room. Then I wish that the director would show me some of that instead.

With balls and ass, a little bit will do you.

Remember that. Recall too that sex, and the artful recording of it on film is about more than just penetration, like we've discussed. It's about capturing the magic that happens when two or more people mingle their bodies and souls. If all you can do is focus on the up close shot of the underside of his balls, you're doing something wrong and probably missing out on something a lot more

interesting.

Show us that stuff instead.

Protecting Your Privacy Artfully

If you plan on locking away your creations in a safe forever and maintaining them as your own private adult video library, you needn't ever worry about privacy. However, part of the fun in making an amateur porn creation is thinking that someone, somewhere, not involved in its creation will watch it. Beyond that, there's always the possibility of an accident. Housekeepers steal. Boxes sometimes get placed in the garbage by mistake. Shit happens. Be realistic about it. Plan ahead. There's nothing wrong with making sure that you'll remain anonymous even if your artful creation accidentally escapes your control. Here are seven simple ideas to help you do just that, in an artful and enticing manner.

A masquerade ball is one in which the participants all wear masks. All of their identities are hidden from each other. This makes the masquerade one of the most fun parties around. Imaginations take over and create realities behind the masks. We'll talk more about using your viewer's imagination shortly. However, for now, know that you can hide your

identity, protect your privacy and heighten your viewer's enjoyment all with masks.

You can just stock up at your local big box store around Halloween, or you can pick up masks on the Internet. But what kind do you get? My favorite, from a participant and a viewer standpoint is the classic carnival mask. Carnival masks are fancy, colorfully decorated Italian masks that cover the upper half of the wearer's face. They help to portray a sexy mystique, protect identities and keep the mouth available so oral fun is still a possibility.

If you don't like the carnival masks, do some shopping and find one that works. However, for full functionality, like I said, try to make sure that the mouth isn't covered. If you want something more sensational, consider a leather, full hood mask with a zipper over the mouth. Just one more artistic suggestion to consider.

There's more than one way to recognize someone's identity. In this day and age with tattoos being as popular as they are, they can identify you as well as a fingerprint. If you're concerned about privacy, you want to make sure that these are covered up as well. Leaving clothing on in a strategic way can help with that. If you have a distinguishing mark on your shoulders or even a sexy tramp stamp, think

about leaving your shirt on. If there's a mark on your legs you can try stockings or even have some wild fun with a pair of chaps. If you feel the need to cover up a lot, try a costume. Dress up can be a lot of fun in porn. When a participant is dressed up in a sexy French maid's costume of maybe a muscly firefighter, no one is insisting that they strip out of it. In fact, leaving it on, leaving skin covered, can actually heighten the fantasy at the same time your identifying tattoos remain hidden.

Remember how we talked about close framing as being a bit limiting artistically? Well, sometimes the need for privacy outweighs our need to create a magnificent opus. By zooming in, tightening up on our subjects during an amateur porn shoot, we can actually cut out people's faces to preserve anonymity. For example, if you'll recall:

Artistically speaking, this shot is limited, however, sometimes the need for privacy outweighs our need to create the best amateur porn movie we can.

If you're going to use framing to hide your identities, you might want to plan things out a little more. By using framing to hide who you are, you set up the shot and then really need to stay in it. You can't move around to much. You and your lover can't roll around and throw caution to the wind while the cameras are rolling. If you do, you'll most likely, accidentally, show your face. That can be removed in post, but it can be a bit of a headache.

Here's what I would suggest. Imagine that you're on all fours on the bed and you want your lover to fuck you doggystyle on camera. Have him get on the bed, you get up, set up the frame based on where he is and where you will be. Then, go get back in the shot and back up onto him. By doing this, he marks the frame and you can be relatively certain that faces will be excluded. Yes, it will be a little more contrived, but it's better than nothing. Artists, in real life, sometimes have to make trade offs.

Camera placement is another technique that you can use to hide your identity.

Framing can only hide so much. You can't show a really good oral sex scene and maintain your privacy with only frame control to help you.

However, by controlling where you put the camera as well, you can. For example, recall back to our discussion on perspective, when we talked about placing a camera in a low position, pointing up, behind the back of a woman giving oral sex. At the time, we talked about how this offered a unique, often unseen way at looking at this sex act. However, the reality is that it can also hide the identities of the lovers during the act, all we have to do is tighten up the framing like I have done in the example diagram.

By tightening up the framing on the behind the back perspective shot we already explored, you can also hide the identities of the participants.

This sort of technique can frequently be used and is

great for any "her on top positions" as well as oral sex shots. It works for both fellatio and cunnilingus. You don't lose much of the magic of the act, and you capture the whole thing in a way that's still fun to watch and even draws the viewer deeper into the movie. They'll be as focused on wondering who is doing what to whom as they are about what's happening.

So far in this discussion of privacy we've talked about using the camera and masks to hide who you are. However, you should understand that people can recognize more than just bodies. If you plan on shooting in your personal bedroom, you might want to stop and think about it for a minute. Your bedroom might be very distinctive. Maybe you'll shoot the view from the window. This alone can be enough to blow your cover to the people who know you.

Shooting in a hotel room will certainly remove the possibility of this happening. Hotel rooms are designed to be anonymous. I've stayed in hotel rooms all over the world. From Argentina to France to Japan to the United States. Everywhere in the world, they all look alike. It's uncanny actually. One is as much the same as another. Shooting in one will help to hide your identity, especially if

paired with masks and the camera privacy techniques I just described.

In addition to hiding your identity, shooting in a hotel room has some perks you should consider. The first is you're making an event out of your naughty video adventures. It's a dirty movie getaway weekend. This will actually help to heighten the arousal and excitement of the sex. You're going somewhere special and you're stepping out of your normal routine. That's a lot of fun to be had for the minimal costs of a hotel room for the night. Throw in a delivered pizza and you can't ask for a better escape from reality.

Another added benefit is that you don't have to clean up. You can really leave one hell of a mess in a hotel room and just walk away. If you do, leave a nice tip for housekeeping, but you're not the one who has to clean it up in the end. You can have your fun and check out the next afternoon in time to go have a lovely, leisurely brunch before returning to your normal life.

Privacy, again, is another big plus for the hotel. You don't need to worry about your kids accidentally coming home from school early. Who knew it was a half day? In an anonymous hotel room you can put on all your studded black leather, tie up your

partner on a St. Andrew's cross and not have to give any concern that someone you don't want involved is going to walk through that door. I mean, other than housekeeping. Again, "Do not disturb" means nothing to them. Take my repetitive advice and make sure you use the chain or bolt when you're shooting.

Lastly, there's room service. Laugh all you want. I'm being serious. I can tell you from personal experience, if you're filming some dirty little scene with your lover, the last thing you want is to have to get dressed and go get a snack. It's no fun. With a hotel that has room service, you make a call and the snacks are on the way. Yes, you'll pay a little more. Yes, you may have to open the door just a crack so the server doesn't see what's going on, but you get the food and you never have to cover your assless chaps. That's a win win.

If you don't want to shell out the money for a hotel room and your bedroom has good locks and you can't find a babysitter, you might consider just using a backdrop to give your set anonymity.

A backdrop is just a piece of cloth hung strategically to create a background. You can find professional backdrop supports online for around $100 or so, plus the backdrops themselves for $20-

$50 depending on what you're looking for. However you don't really need to spend that for what you're planning. Those backdrops are really nothing more than loosely woven cotton in most cases anyway.

If you want a simple backdrop, all you need is a big bed sheet and some thumbtacks. That's really what a flat sheet is for. Sheet makers won't tell you that but it's true. Just pin the sheet behind your bed. After all, one bed looks much like another with some sheets hanging behind it. You can do it either along the long axis of the bed or behind the headboard. For maximum flexibility, do both. This will give you 90° that you can shoot against.

When I've done this, I prefer to use beige another soft color. No white! It confuses the cameras. Using non-white helps to avoid exposure mistakes from the cameras. They also help with the lighting. The light colored fabric actually reflects a bit and helps to create that soft diffuse lighting we've talked about so often. Whatever color you choose, check it in the camera first and make sure you like what you see before you start rolling. If you don't, use another color.

If you haven't liked any of my ideas for preserving your anonymity up to this point, you can always

rely on post production blurring. Post production blurring is when you use software to create a blurred image over a person's face in your footage. This is accomplished through a technique known as Gaussian blur. Gaussian blur uses a computer algorithm to distort the video and create a blurred effect. This will pretty effectively remove identifying features from the footage.

As there are a million different video editing softwares out there, I'm not going to give you anything specific. Feel free to do an internet search with the phrase "Gaussian blur" plus your photo editing software's name. If it can do it, I'm sure you'll find a video tutorial specific to you. If you haven't bought video editing software already, make sure you find out if the one you're looking at offers this feature (most do) before you buy anything.

If you have your heart set on creating great amateur porn and hiding who you are, one of these techniques, or a combination of several should do the trick. However, you would be wise to remember that nothing in life is 100% and the best way to make sure you aren't recognized on your porn production is to just not shoot it in the first place. The bottom line is that your privacy, cannot be 100% guaranteed. Again, shit happens and the

ultimate responsibility, as well as the consequences for your actions lies solely with you. Ask yourself before you record anything, if you're so concerned about being recognized; should you be making amateur porn in the first place? I'm talking to all you politicians, teachers, preachers and celebrities out there.

Don't say I didn't warn you.

No Peacocking

This is a little redundant with other parts of this book, but I feel that it's worth reiterating before we finish our discussion. It's that important.

One of the worst things you can do to your amateur porn is to put on a show. In short, people ignore my advice on ignoring the cameras and try to "sexy" up their porn. They talk to the camera. They talk dirty to each other in awkward, forced, unnatural ways. They make their sex noises louder and flamboyant. In short, they ham it up.

Avoid all of this. Acting is hard enough as it is. Acting in a porno movie is even harder, especially an amateur one. In most cases, you're just going to record yourself and your lover in a cheesy, sexual situation and any real passion, magic or sexiness

will evaporate in front of the camera.

Sex, by its very definition is, sexy. People want to see it. They want to watch it and they want it to be real. It's real when you don't try to put on a show. It's real when you ignore the cameras. It's real when you let the sex unfold naturally without any direction at all. You just need to let it happen. When you do, you'll find that what you've recorded is much better.

A Good Porno Tells A Story

You might think what I'm about to say is silly, pretentious, arty crap. However, I'm the author of this book and that means that I get to say whatever I want. This is a perfect example of that liberty.

Good porn, like any film, tells a story. Yep, a story. The better that story is told, the better the finished film.

What do I mean by this?

First off, I'm not telling you to write a script and dialog for your amateur porn. Please don't, as a matter or fact. It will seem fake and cheesy and will make your amateur porn no fun to watch, like I've said. Leave that to the professionals.

What I mean by this is that people on camera, doing things tell a story. Imagine a bit of amateur porn that seems to be set in a dorm room. There's a man in the room. A woman walks in and the man greets her. Already from this description, you can picture a scene and you can infer things about the people in it. The room is small. The furniture is cheap. The camera may be hidden. The people are young. They're probably in college since it's in a dorm. He was sitting there and she dropped by for a visit. The story is shaping up nicely.

Now, imagine that the couple (a man and woman) begin to kiss. It's passionate. They're really into it. They seem to be enjoying themselves. The enthusiasm is high. He stands up. She drops down to her knees. He can't pull it out fast enough. She begins to give him a blowjob, again with enthusiasm.

Note that no mention of dialog has been made at this point in this example. No one has told you anything other than what you would see as you watched a silent film. Imagery alone told you all that you know. The couple was kissing enthusiastically. Maybe they haven't seen each other in a while. Maybe their relationship is young and the passion is high. Either one of those is

believable. A film or a story does not have to tell you exactly what you should think. In fact, it's often a strength when everything isn't explained. However, you could see how your mind would fill in the details and make sense out of what you're seeing. It's a personal, intimate narrative and you, the viewer, are involved in creating it in your own head. That's what good film, especially good porn does.

Next, imagine that she stands up. They resume kissing with the same passion as before. Then, she bends over, pulls down her pants and he enthusiastically enters her. She's bent over the desk, the camera recording her facial expressions as he slams into her from behind. You can't even see the intercourse. The sex isn't long lasting. He slumps over her as his face clenches and he appears to cum. They slump together for a minute. They're motionless. After a bit, they stand up. He pulls up his pants. She does the same. He collapses into the desk chair. She kisses him quickly, as though to say goodbye. She grabs a backpack and leaves the camera frame.

From these last details, you might be tempted to infer that this woman swung by her boyfriend's dorm for a quickie in between classes. She didn't

have a lot of time. She had a backpack like she was running off somewhere. They seemed to be in a hurry. You could also infer that maybe the two were rushed because a roommate was coming back soon. Either way, you can tell that they had to hurry. That's another bit of the story that's told through this silent bit of imaginary amateur porn and your mind will fill in the blanks to make sense of the story.

The scene that I just described could easily be less than 5 minutes. Like I said, a quickie. It would be very easy indeed for a couple to have some quick sex in a dorm room like this and to record it. However, you as the viewer, would easily have been drawn into this. The film told a story. It didn't fill in every detail, but it certainly told you a little about the people in it and it told you a little about their lives, their sex lives to be exact. It also involved you in it, and forced your mind to create the narrative.

I kept this example short to illustrate my point. This scene was a very natural one. It could easily happen in real life. You could easily stroll through a college campus and realistically believe that anyone you saw might have had an experience like the one I described. The example was believable and it had a realistic quality from start to finish.

That's what good porn does.

Now, imagine the opposite. Imagine a close up of a cock and balls just going into a pussy. That's all. That's the whole frame. There's nothing more than that. This doesn't tell you anything more than a cock is going into a pussy. Well, I've seen that a million times and it still isn't at all interesting. I can see that anywhere. There's nothing in that to involve the viewer, to draw them into the lives of the participants or to make them a part of what they're seeing. All of the advantages and the appeals of amateur porn are lost in a situation like this.

Start with the foreplay. Undress on camera. Or don't. Stay clothed and fuck like that. Make love. Fuck some more. Finish. Cum. Cum again and then fade to black. All of life, all of sex, is a story waiting to be told. When you make an amateur movie, you capture a part of that story for all time.

How will you capture yours?

Consider Using White Noise

Sex is not always noisy. This is usually not a problem when you're actually having it, but it can be a problem when you're filming it. Professional

porn captures all the noise with a boom microphone. You will not have that luxury and you might wind up with a pretty quiet film. Music and sound are essential components to making video interesting. All you need to do to prove this to yourself is to watch a movie and pay attention to the score. Filmmakers use music to set mood, break up otherwise silent scenes to keep the audience interested and to convey emotion. Movies that we all love would seem flat and lacking without their beloved musical components. I'm sure you can imagine some prime examples.

You're always welcome to add some sort of musical overtone to your videos in post production, but you might also want to consider adding noise while you're filming. This is one of those things that you might need to experiment with before you find something that you like and thinks works well. Test it out first! However, I'll give you a couple of ideas to ponder.

You can always play music in the background while you are getting it on. That's the most obvious solution and this can really make for much better viewing. Depending on the music you choose, you can easily convey all sorts of emotion. Soft, tender, sooth jazz implies romance. However, you can just

as easily give the viewer a sense of wild domination sex with a hard rock song. There are as many possibilities as there are songs. Have fun and, like I said, play with it.

This is one area where you might want to be careful if you're planning to sell your porn at any point however. Music and radio broadcasts are copyrighted just like anything else. If you release a porn movie with a song in it, you could be violating copyright laws and exposing yourself to a lawsuit. For information on doing this, and complying with copyright laws, speak to an attorney. Always obey and abide by all copyright laws.

Water is another great white noise that you can use. You can always run the shower and play around with some sort of wet soapy shower sex scene. Actual intercourse in the shower can be tricky, but it makes a great foreplay scene or a place for wet oral sex. The noise of the water will fill the audio void very easily. Frothing hot tub jets are another way that you can create white noise with water. If you find yourself in a hot tub having sex in front of a camera, turn on the jets. Don't just let the water lay flat.

If water isn't handy or lubrication is a problem in the water (it really can be) you can always try a fan

or an air conditioner. These are easy to find sound generators that will provide great white noise.

Those are just a couple of suggestions to add white noise to your movies while you shoot. Try them out. See if you like them. If you prefer quiet movies great. However, I think you'll find, like me, silence can be distracting. You can, if you choose to, always add music in post production.

If your sex is wild, loud and acrobatic, don't worry about the noise. If oral sex in your bedroom is loud and slurpy, great! Record that! That's part of the magic too. Just make sure you're giving some thought to the sounds you're recording as well as the images. It doesn't have to be equal consideration, there should just be some. If you do, you'll make better porn.

The Unopened Door

If you spent a lot of time studying horror movies, you'd learn something pretty quick. Most of the time, at least in classic horror movies, directors are reluctant to show you their killer/monster/space alien. There's a very real reason for this. The truth is, that by hinting at, and alluding to the terrible nature of these creatures, directors can get better results. What do I mean?

In reality, by leading your mind to a conclusion, like what's behind that door is just awful, your mind will create something much scarier. Here's how it works. Imagine I, a horror director, hint that there's a terrible, scary monster behind an unopened door. I might tease you by making the door bulge like something is pushing its way through it. Maybe I let you hear some terrifying noises too. Maybe I let you see glimpses of something that's too dark to be anything definite. What happens? Because you can't actually see the terribleness, but you know through my leading that it **IS** terrible, your mind will do the rest of the work for me. Your imagination takes over.

Your imagination will fill in all the details because most people just hate the idea of not being able to see the terribleness. In addition, your mind will customize the terror and horror by using your own fears to create the detail. By starving your brain of the visuals it craves, I can actually trick your mind into creating a terror far scarier, far more personal and far more real than I could ever do with just special effects.

The same technique can most definitely be used in porn.

If you, as the director/producer, hint at and allude to

sex, the viewers mind will often fill in the essential details for you. Human minds just do this naturally. That's what imaginations are really good for. Don't forget that by using your viewers mind to create the effect you want, you're doing so in a way tailored to their particular turn ons. For example, by teasingly not revealing a pussy, a viewer may fill in the image with a pussy from their own memories. This in turn will be charged with additional emotions and fond memories. The resulting imagined pussy will be much more arousing to them because of all the added personal connotations.

It really is sexier to conceal than it is to reveal sometimes. Don't always feel that you have to show everything in stark, high definition, microscopic detail. Arty, grainy and concealed will frequently do a better job of connecting on a personal level with the viewer. Deciding when to use which technique will be your challenge as the artist. But, it's also a lot of fun.

Artful Exposure Manipulation

Exposure settings on a camera are the settings that determine how light or dark the recorded images are. Modern video cameras make this determination for you based on the amount of detected light in the room. Most of the time, unless

you've avoided my good advice and are filming against a white backdrop, the exposure settings that the camera calculates will be just fine.

If for some reason, you do not like the conclusions that the camera makes, you can adjust these manually, most of the time. Go get your camera's manual (I know you saved them) and look up "exposure compensation". The exposure compensation will allow you to manipulate the camera's settings to manually lighten and darken the frame.

So, if you ever think your shot is too dark or too light, that's how you fix it. Pretty simple.

There is an artful technique that I have used in the past that belongs in this little book though, so I'll include it here. I like to call it "Artful Underexpose".

When you use the artful underexposure technique, what you do is you manually darken your recordings. By doing this, you actually create footage that obscures a large part of the sex. Why on earth would you do this?

I have done this for two reasons. The first is that by artfully underexposing the footage I was recording,

I created the illusion that the film was made by someone who had no idea what they were doing. Underexposed footage is something an amateur would do by mistake, and it was something I first started experimenting with when I was anything but. However, the end result, which I deemed very watchable, wound up looking like something some drunk amateurs would create in a hotel room. It had an artificial "realness" to it.

The second reason that I originally started playing with this, was as a way to implement the "unopened door" concept we just talked about. By artificially darkening the frame, I obscured and hid much of what was happening in the room. Yes, you could still see things. Yes, you could still see the sex and yes, it was still clearly a graphic amateur porn, but much of the detail was gone. It was my hope, as the artist, that this would result in exactly what I described in the last section. A porno that forced the viewer to fill in the details from their own mind to the result that they were involved with the footage in a much more emotional, personal and connected way. In my opinion, as the artist, it worked.

I'm including all of this information, for the same reasons I've filled the pages of this book. I want to

empower you and give you license to try things out. Don't be afraid to play with exposure settings and to try to implement the unopened door concept in your own amateur porn endeavors. You might just like what you come up with.

Persistence Is A Necessary Ingredient To Success

Rome wasn't built in a day and if you're expecting to create a stunning amateur porn masterpiece on your first attempt, you may be in for some disappointment. The chances are very, very, very good that you'll create footage that can be improved upon. Accept it. That's just life.

The first time you had sex wasn't great either, but you kept at it and it got better.

Beyond accepting this fact, you should make a resolution to yourself. You need to keep trying. Keep working at it and you'll notice that the quality of your creations will begin to go up a lot. Each time you'll learn something new or perhaps try something different that'll make your porn better, prettier, more captivating or steamier. That's just a fact. Version 2.0 is usually a lot better than Version 1.0.

The trick is understanding and embracing the fact

that what you make will probably not be very good the first time. Make a promise to yourself that you'll keep at it. Seriously, do it right now. Promise yourself that you'll keep at it. Promise yourself to keep the cameras running. Promise yourself to keep working at it to make better footage. Promise yourself to keep innovating, trying new things and working to make the best possible footage you can. Perfection is elusive and hard to catch, but the people who capture is are the people who keep chasing it. You need to be one of those people. If you are, and you keep focusing, the rewards will be worth the challenges that you overcome.

Most importantly, promise yourself to keep having fun in front of the cameras. This is the most important part. You and your lovers should never lose sight of the fact that the cameras are there because you're having sex, not the other way around. Have fun in the bedroom. Play. Laugh. Enjoy each other. Get lost in a million true moments and let the cameras run. When you're having true fun, you'll find that you forget the cameras are there and you'll just focus on each other. Then, my friends, is when truly magic moments are captured on fil

Appendix

Some Brief Tips On Post Production

I'm not going to spend too much time discussing video post production. The truth is that this is a rather complicated, technical field that could easily fill up many books of this size. If you're interested in all the complexities, technicalities, and nuances of video post production, I would strenuously recommend that you first find a computer program that you like. Then do some serious reading on how to use all of it's various features.

The truth is that you don't need to be a master at video editing to complete your amateur porn. Most of the work has already been done during the production phase of your project. By spending time on lighting, camera placement, white balancing, framing and all the details that go along with these topics we've already discussed, you'll already have created some pretty good amateur porn. You're probably not going to add animation or special effects to these recording. Instead, you're probably going to want to be able to splice together and edit your various recordings and you're going to want to convert the video to different formats. Add to that some filters, a little Gaussian blurring, maybe an audio tweak or two, some exposure compensation and we've probably covered all that an amateur porn producer is going to need to do in post.

My aim in this appendix, like I said, is not to teach you how to do all of these things. Again, that's complicated, technical and specific to the computer program you choose to use. Instead, I'm going to give you information like I did with video cameras. I'm going to introduce you to broad concepts and show you what questions you need to ask when you go shopping for a program. In addition, I'm going to introduce you to some useful resources for an amateur porn producer including where you can get very good, reliable and free video editing software. Once all of that is done, I feel that you'll be sufficiently empowered to take the ball and run with it on your own.

Let's begin.

There Are Two Types Of Video Editing Software

When you go looking for video editing software you're going to learn that there are two different kinds of programs out there. It's important that you know what they are and what they do.

The first of these software types is called "Non-linear editing".

Non-linear editing is what people usually think of when they think of video editing software. This is

the software that allows you to to cut and paste bits of video together. You can rearrange scenes and capture still images. This type of software draws its name from the early days of film editing and the name has stuck ever since.

The other kind of software out there is called "Transcoding" software.

Video in the digital age can exist in many, many different formats. Essentially any video file is nothing more than a large collection of ones and zeros. However, with the myriad of video playing software that exists, there are many different ways to combine those ones and zeros. Unfortunately, video players are often specific as to which file types they will and will not play. If your file is of Type A and you have a player that only plays Type B, you have a problem.

That's where transcoding software comes in. Transcoding software will convert Type A data files into Type B data files and so forth.

Now you might be tempted to think that this is something that you won't need in your amateur porn adventures. It's possible. But the truth is at some point when you and your partner change equipment or update your computers or software you'll run into

a data file conflict. The dreaded error message will come up saying this or that software can't play your file for one reason or another. Then, you'll tear your hair out in maddening frustration trying to get everything to work again.

A transcoding software can help you avoid all of that.

When you go looking for a video editing software, you should make the effort to find one that offers both of these features in one program if possible. Many of them do.

Finding Software

You might feel that you need to go out and spend a lot of money to get a video editing software that will work for you. The truth is that you can jump online, do a little research and order a completely usable, user friendly video editing software for a very reasonable price from any number of respected software manufacturers. Plus they're often downloadable, which offers instant gratification.

There are a lot of options out there and, for what we're talking about here, most of them will do very nicely. However, before you go out and spend any money, again, take a little stock and do a little

checking around first. Remember, one of the themes in this book is to dip your toe in the lake, not to dive right in. There are a couple of options you should explore first before you shell out any more cash.

The first of these is to see if your video camera, if you just bought one that is, came with a video editing software. Many video cameras will ship with a basic editing software that is specifically designed to work very well with your camera. Spend a little time looking in the box and check out any media that shipped with your camera. Read the instruction manual! See if it makes reference to any software. If there is any, the manufacturer will not have made it a state secret. It should say it somewhere on the box, on any DVDs, or in the manual.

I've definitely made use of the software that came with one of my cameras. I have been very pleased with it up to this point. In the case of that unit, the software is loaded right on the camera and loads up automatically when I plug in the camera via an HDMI cable.

If there's something with which to do editing, load it up and play with it. Jump online again and see what people are saying about it. In short kick the tires

and see if it'll do. It just might. You're needs are pretty basic.

Now if your camera didn't come with software, or you decide for one reason or another that you don't like it, I do have another option for you that will more than make up for the cost of this book. Yes, I'm still trying to make this a good value purchase for you and I'm trying to save you money.

The little pearl that I'm going to give you is called "Open Source Software".

Open source software is a type of software that's developed by volunteer programmers from around the world. Don't laugh. This is serious software for serious users and it's very reliable. Plus it's free. In fact, most of the computer servers that power the internet run this type of software.

Until the last, say five or ten years, this software has really been the exclusive province of computer enthusiasts and programmers. However, more recently, many programs have been developed for the home user in mind. Many are very good indeed. I use open source software often and I'm a fan of it both for its quality and price.

All that being said, there are some very good video

editors that fall into this category of software. They are easy to use. Well built and best of all, they're free.

To find this software all you need to do is an internet search with the phrase "Open Source Video Editor". "Open Source" is a type of software licensing. You should be able to, with this search phrase, to find a list of available software. Again, do a little research, look around and try some out. You know what to look for at this point, namely non-linear editing and transcoding abilities.

You might find something that will work for you very well and it won't cost you a penny.

If these two approaches don't offer you something that you like or feel comfortable with, by all means jump online, pick out a commercial editor, order it and download it. You'll have done your homework and made an educated decision by that point.

Internet Tutorials

Whatever software you wind up choosing, I want to make sure you know about the wonderful world of internet tutorials. They will be a very good ally in your quest to master the particular software you just bought. Most of the time you can find these

tutorials for free.

When software and home computers first became commonplace you needed to buy a book that was thicker than a phone book to learn how to use them. The books were technical, in depth, expensive and took up a lot of room on the shelf. In addition, ironically, you usually only bought the book so you could figure out how to do one stupid thing. You learned it. You remembered it and you never opened the book after that. It was money and shelf space well wasted.

You don't have to do that anymore.

Thanks to the prevalence of video cameras and the availability of broadband, the internet is now chocked full of tutorial videos. These are an absolutely indispensable resource when you want to quickly and easily figure out how to do something whether it be re-tiling your bathroom, changing a part on your car or figuring out how to seamlessly integrate multiple amateur porn videos into one amazing montage.

Again, if you need to figure out how to do something in your software, just do an internet search and you should find a short video answering your question in specific detail. Try something like

"Using Gaussian blur in *your software's name*".

I would be shocked if something didn't come up to quickly answer your question. I use these tutorials all the time for many different areas of my life from the technical to the basic. They have been a very valuable resource that I would miss were I forced to give them up.

You owe it to yourself to keep this great tool in the back of your mind and to draw on it when you run into something technical that you don't quite understand in your post production.

Don't Lose The Spirit Of This Book In Post

To continue another theme that we've talked about a lot in this book, when you first start editing together and making finished amateur porn videos, keep it basic. You don't need to go nuts in post production to wind up with something that's a lot of fun to watch. Like I've said, most of the really hard work, the lighting, framing and camera placement has already been done. You and your partners have already, hopefully, filled the video recording(s) with the energy of real people, real sex and real pleasure.

All you're doing in post production is combining the video recordings into a single, artful recording of

the whole sexual encounter. All that really means is non-linear editing on a basic level.

Start small and slow. Do the least amount of work that's necessary to properly represent and convey the story and imagery that you want to share. This is another one of those areas where less tends to be more and a softer hand usually creates something better in the end.

Plus, don't be afraid to scrap what you've done and start over. It's OK. Periodically, good artists have to step back from their work and start over. Persistence in post production is as important as it is during the production phase. Play with it. Try different things out. Be flexible. Don't lose the fun and you'll eventually wind up with something that you are really proud of.

This brings us to the end of our discussion. Thank you very much for purchasing this book and I wish you all the luck in the world in your amateur porn endeavors. Have fun and create something beautiful!

www.ingramcontent.com/pod-product-compliance
Lightning Source LLC
Chambersburg PA
CBHW031050180526
45163CB00002BA/770